POSTCARD HISTORY SERIES

Temple

IN VINTAGE POSTCARDS

POSTCARD HISTORY SERIES

Temple
IN VINTAGE POSTCARDS

Michael LeFan

ARCADIA
PUBLISHING

Published by Arcadia Publishing
Charleston, South Carolina

Printed in the United States of America

Library of Congress Catalog Card Number: 2004110244

For all general information contact Arcadia Publishing at:
Telephone 843-853-2070
Fax 843-853-0044
E-mail sales@arcadiapublishing.com
For customer service and orders:
Toll-Free 1-888-313-2665

Visit us on the Internet at www.arcadiapublishing.com

CONTENTS

ACKNOWLEDGMENTS

When you write something about the history of a place, you are immediately indebted to authors and historians who have gone before you. They are the reason that we know what happened back when. In fact, the later you arrive in the historical chain, the luckier you are, in a way, because you have the advantage of viewing a more complete picture. Fewer pieces are missing from the puzzle.

In writing this book, I have enjoyed reading (again) and I am indebted to books by other authors. I mention the following sources because they are the ones I turned to most: *Bell County Revisited* by Martha Bowmer; *The Prairie Queen and Her Choo Choo Train* by A. Bryant Messer; *On the Edge of the Black Waxy* by Oscar Lewis; *Men of Steel, Women of Spirit: The History of Santa Fe Hospital* by Patricia Kay Benoit; *With Scalpel and Scope—A History of Scott and White* by Dayton Kelley; and *Temple—Everything You Ever Wanted to Know About Temple, Texas but Were Afraid to Ask* by Harley D. Mitchell. I also relied on *The Handbook of Texas Online* (www.tsha.utexas.edu/handbook/online/), a joint project of the General Libraries at the University of Texas at Austin (www.lib.utexas.edu) and the Texas State Historical Association (www.tsha.utexas.edu).

Most of the postcards illustrating this book are from my own collection. However, several people generously shared either their own vintage postcards of Temple or the postcards of a collection over which they serve as curator. I must thank Mary Irving, curator of the Railroad and Heritage Museum for access to their extensive collection, and send a thank-you to Craig Ordner, archivist, for his friendly assistance in reviewing those postcards. Thanks to Helen Vaughan for loaning me her old and rare postcards. And thank you Brenda McGuire for allowing me access to your tremendous postcard collection. Thanks to Percy Francis for his life-saving contribution. Thanks also to Susan Groveunder for sharing the photo collection of her father, J.H. Roeder. Although not represented in this book, the Temple Public Library also has a respectable collection of antique postcards of Temple scenes. Thanks to John and Brenda Carter and Tom Vanderveer for their help. I also appreciate the assistance of the Curt Teich Museum in Illinois.

Keep in mind that this is not a history textbook. Instead, it is more of a remembrance and reverie by someone that has lived in Temple since age 4 and is now 58 years old. Things have changed since I got here in 1950, but I am pleased to report that Temple, Texas, remains a special place.

INTRODUCTION

Have you ever wondered what it would have been like to journey across the United States in the 1800s? I enjoy thinking about what it would be like to live in Temple, Texas 100 years ago. I can imagine riding a train across vast miles of Texas landscape, traveling through open countryside and small towns, and finally arriving at the new village of Temple Junction back in 1881. I think of what are today the landmarks of Temple and envision those locales before the landmarks were constructed.

I have a passport to that long-ago world: the picture postcard. From the 1890s through the 1920s, postcards were an extraordinarily popular means of written communication, and many of the postcards from this "golden age" are today considered works of art. Postcard photographers such as Curt Teich, Raphael Tuck, and numberless local photographers crisscrossed the United States snapping photographs of bustling street scenes, recording local landmarks, and rounding up groups of local townsfolk eager to "have their image struck" for posterity. These images were printed as postcards and sold in general stores across the country. They survive today as telling reminders of an important era in our nation's history.

This new retelling of the story of Temple, Texas, displays nearly 200 of the best vintage postcards available. Collected and interpreted by Michael LeFan, the long-ago images in this informative volume provide an enchanting trip down memory lane, bringing the early days of Temple's history to life for visitors just passing through and for those too young to actually remember those days.

When the U.S. Post Office began allowing people to write a message on the back of a picture postcard in 1907, the idea took off like a rocket. The card could be mailed to anywhere in the country for only a penny. As amazing as it sounds, a postcard mailed one day could be received by the very next day! Ah, progress.

Postcard views are now sought after and highly prized by many museums, libraries, and individual collectors. The cards serve as a visual historical record of the past. Whether it is a view of Main Street, a local church, an old school, a long-gone roadside attraction, or the undeveloped countryside, postcards mirror the way people once lived. Frozen for the ages in these old pictures are nostalgic images of people in the dress of their day, at work, at play, at school, or at church——frequently with their Chevys, Fords, or Reos. These postcard views provide a window back in time. Through the magic of postcards, let's wander down memory lane!

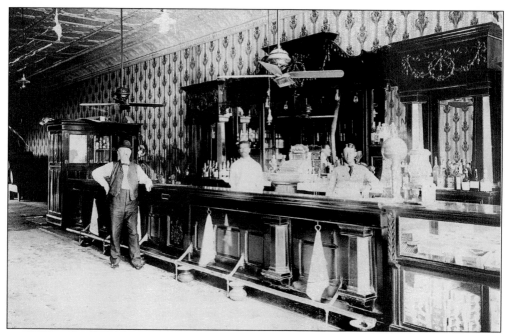

A Saloon on Every Corner. Mrs. Saxon, a local temperance leader, drew a large crowd of men, women, and children in 1885 for her presentation on prohibition. Like other civic-minded souls, Mrs. Saxon was concerned about the proliferation of saloons in early Temple. the *Temple Times* reported, "She handled arguments, statistics and history in a manner worthy of her cause." The patrons of this saloon do not appear concerned. (Courtesy J.H. Roeder Collection.)

One

WELCOME TO
TANGLEFOOT

Temple was born a rough railroad town created by the Gulf, Colorado & Santa Fe Railway Company. The town was conceived in 1880, when Jonathan Ewing Moore sold 187 acres of farmland to the GC&SF as the site for a construction camp. The railroad laid out a town plan and auctioned off lots on June 29, 1881. The railroad needed a junction point to service railroad equipment, passengers, and employees. The GC&SF christened the site Temple Junction in honor of Bernard M. Temple, chief civil engineer of the railroad, who built the tracks through Bell County. A Virginian by birth, Temple became an expert civil engineer while working in Kansas, Nebraska, and Eastern Texas under the tutelage of Octave Chanute and Grenville Dodge.

While this new town was labeled Temple Junction on railroad maps, residents called it Mud Town or Tanglefoot, a commentary on the waxy clay soil. Street conditions during wet weather caked feet or wagon wheels with growing layers of gooey mud. When a post office was established in January 1881, the town became just Temple, Texas—no longer Mud Town.

The town was created when the GC&SF purchased those 187 acres of farmland from Jonathan Ewing Moore for $27 an acre, which many thought was an astronomical price for land with limited water sources. The railway announced an auction for the property. Trains brought prospective buyers from five Texas cities and those who purchased property were refunded their ticket price. After June 29, land continued to be sold to new residents for $45 to $300 a lot from Moore and other sources. Eventually, the trains brought families of railroad workers, and they began transforming Tanglefoot into the town known as the "Prairie Queen."

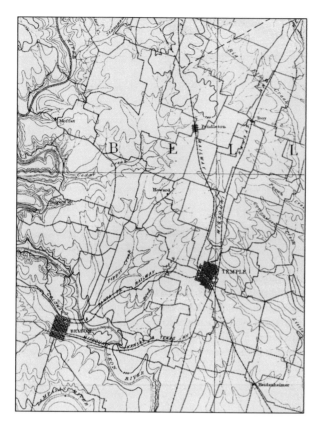

DETAIL OF AN 1892 MAP OF BELL COUNTY. This segment of a topographic map shows the cities of Temple, Belton, Eddy, Bruce, and Pendleton, and the smaller settlements of Heidenheimer, Howard, Oenaville, Oker, Barclay, Moffat, Troy, and Cyclone. Of particular interest are the 1890 railroad layouts of the GC&SF and the Missouri, Kansas, & Texas Railroad (MKT or Katy). This map was produced by the Department of the Interior, Franklin K. Lane, secretary, and the U.S. Geological Survey, George Otis Smith, director.

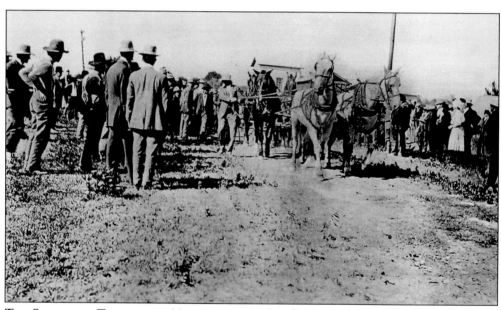

THE STREETS OF TANGLEFOOT. Newcomers arrived in the town of Temple by way of wagon as well as train. The arrival of new citizens caught the locals' attention, and they turned out to meet and greet them. This really was the "welcome wagon." (Courtesy J.H. Roeder Collection.)

GULLY-WASHERS AND DRY SPELLS.
During a long dry spell in the summer of 1891, four "scientists" from the Kansas Artificial Rain Company set up shop in Temple, the first city in Texas to try rainmaking. Mr. Murphy, company president, assured the public that his process did not involve the usual dynamite charges. His team was secretive, carrying out observations from a house in south Temple. After several days, they announced that rain would come on Friday. That Thursday night, blue flames were noted in and around their facility. Friday dawned clear as a bell, but before evening, the rain actually

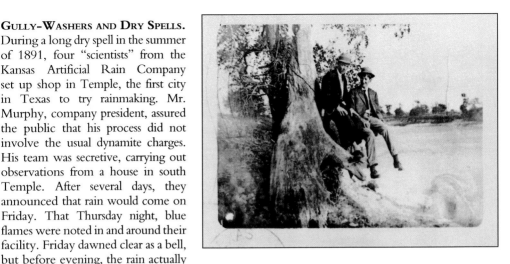

fell. In more traditional efforts, Santa Fe Railway dammed Bird Creek and created Lake Polk for refilling their steam engines. Lake Polk still exists as part of Sammons Municipal Golf Course. Later, using the slogan "Leon or Bust," a privately owned water company began piping water from the Leon River south of town. The city government eventually took over the responsibility of supplying water. These two young men found water by dangling their legs over the banks of a creek or river—perhaps the Leon River or Bird Creek—in this *c.* 1909 view of Temple.

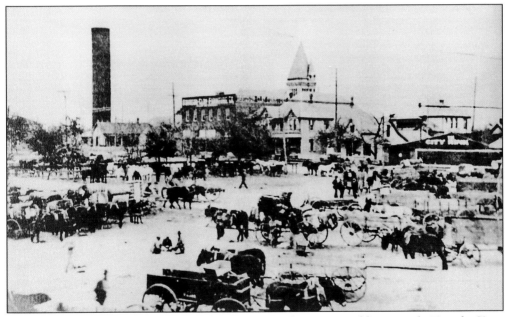

WATER, WATER . . . NOT EVERYWHERE. Water posed a serious problem in early Temple. Since the city had no inexpensive natural source of water, people dug wells, some dug cisterns to hold rainwater, and enterprising souls sold water for 50¢ a barrel. Temple tried several projects to solve its water problem, including a huge water stand pipe (seen here), which promptly collapsed when filled with water, killing two people and flooding downtown in 1905. The Kyle Hotel now stands at this location. A second water stand pipe replaced the collapsed one, and helped ease water shortages. (Courtesy Temple Public Library.)

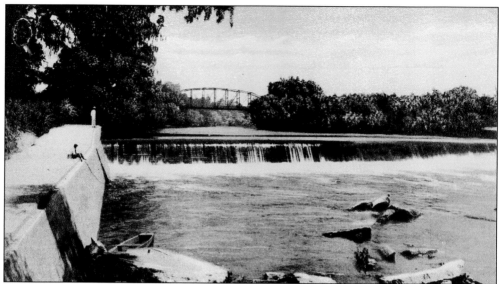

THE LEON RIVER. Before 1858, homes stood along the riverbanks. However, flooding hampered transportation. Ferries and toll bridges allowed crossings during flooding, and in 1890 Temple began drawing its city water from the Leon. Dams and reservoirs provide flood control and water supply for area cities and farms. (Curt Teich, distributed by Barton's News Agency, Temple.)

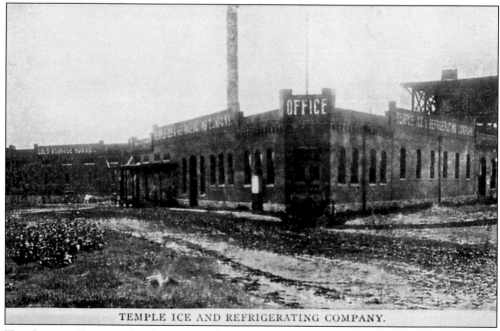

TEMPLE ICE AND REFRIGERATING COMPANY.

THE ICEMAN COMETH. By the spring of 1894, the Temple Cold Storage and Ice Factory was furnishing ice to the Santa Fe. Residential ice customers put a sign in their front window ordering either a 25- or 50-pound block. The iceman chipped it off a large block in his wagon, gripped it with tongs, heaved it onto his leather-protected left shoulder, and carried it to the icebox. (Courtesy Helen Vaughan.)

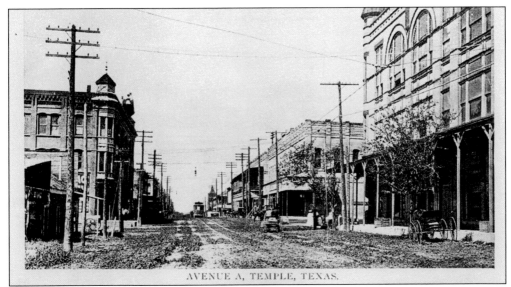

AVENUE A, TEMPLE, TEXAS.

AVENUE A. This dirt street reveals why Temple was known as Mud Town and Tanglefoot. After a rain, life ground to a halt. Wagons mired in mud were abandoned for days at a time. Even trips to the cemetery had to be postponed when rain made the streets impassable. Curiously, three colors of horse-drawn hearses were used: white for children, gray for adults, and black for older people. (Courtesy Railroad and Heritage Museum.)

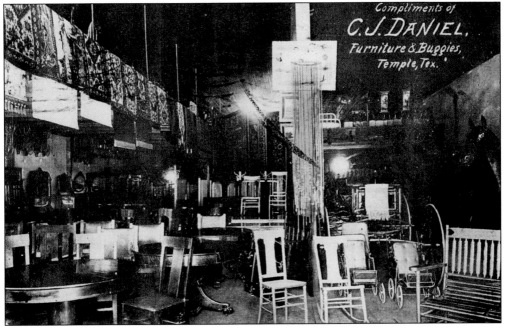

Compliments of
C.J. DANIEL,
Furniture & Buggies,
Temple, Tex.

A POSTCARD ADVERTISEMENT. This early example of direct mail advertising says, "Compliments of C.J. Daniel, Furniture and Buggies, Temple, Texas." The postmark on the card reads 1910. L.G. Sims, who moved his family from Birdsdale to Temple, opened a store in the new town, in a wooden building at 124 South Main Street. He sold groceries and general merchandise. Temple absorbed the Birdsdale settlement. (Courtesy Railroad and Heritage Museum.)

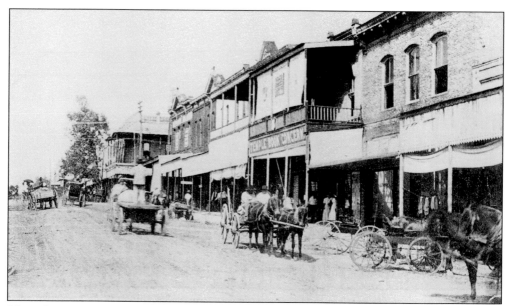

MAIN STREET. At Rogers' Drug Store, pharmacist O.L. Hargrove sold such over-the-counter items as Parsons pill, "a dual purpose medicine guaranteed to produce rich blood in humans and also to cause barnyard hens to lay." Others merchants included Mrs. Sherrill's Millinery; Schwartz' Twelfth Street Bakery; Anglin & Sons, Mattress Manufacturers; Taylor & Jackson Meats; Mrs. S.P. Atkinson, "Fashionable Dressmaker;" and Weathering's Fine Photographs. (Courtesy Railroad and Heritage Museum.)

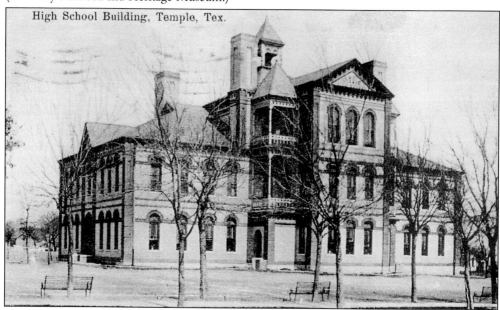

High School Building, Temple, Tex.

HIGH SCHOOL BUILDING, C. 1910. The town's first school was a private one, founded by Miss Jeannie McConnell and Mrs. Ida Sebastian in 1882. Residents formed the Temple Independent School District in 1883. W.T. Hamner was superintendent when Temple High School graduated its first class in 1890. The graduates were Kathrine Sloan, Ray Wilcox, and Alice Robbins. (Courtesy Railroad and Heritage Museum.)

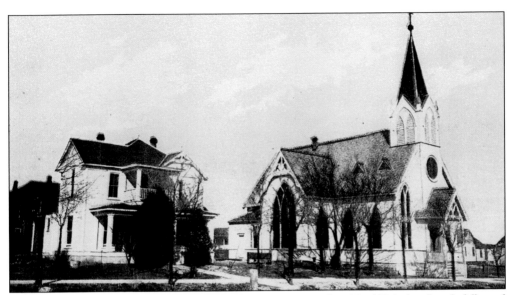

St. Mary's Church and Rectory. The rectory was completed in 1894; the church followed in 1895, near Seventh Street and Avenue g. P.A. Heckman, rector of St. Mary's Catholic Church, created a church-on-wheels in 1918, taking mass to the farmers and their families, mainly in rural, eastern Bell County. He packed his mobile church with folding chairs, an altar, and the needed vessels. (Courtesy Railroad and Heritage Museum.)

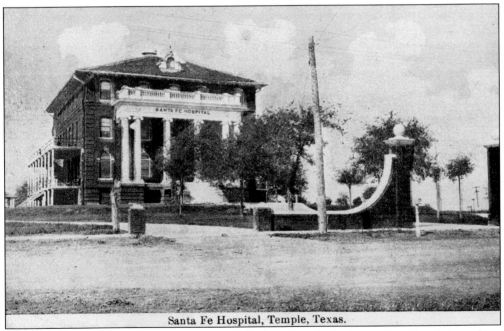

Santa Fe Hospital, Temple, Texas.

Sante Fe Hospital. The Santa Fe forever linked the town's destiny to the railroads by making Temple a junction and division point. The GC&SF founded Santa Fe Hospital to serve the growing railroad population living in Temple and because of its centralized location for other Santa Fe employees. This facility cast a long shadow regarding Temple's eventual growth as a world-class medical center.

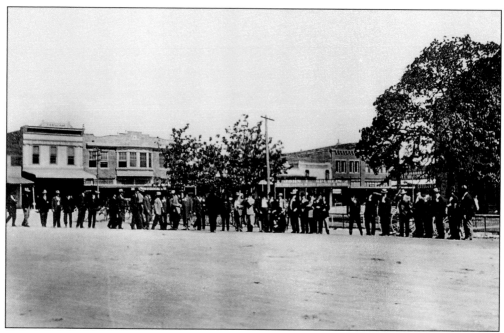

MAYBE IT WAS SATURDAY. The country dwellers came into town for supplies, to sell their produce, and to enjoy some entertainment on Saturdays. Maybe that explains this crowd of people in old downtown Temple. Whatever their reasons for gathering, this gives us another glimpse into how life looked to Temple's residents in the late 19th century. (Courtesy J.H. Roeder Collection.)

Two

TANGLEFOOT BECOMES
THE PRAIRIE QUEEN

Temple was a planned community, laid out before the people arrived. The town was tough during its first years. Saloons and working girls conducted most of the commerce. However, as railroad men began moving their families to Temple, the character of the place blossomed. Instead of Tanglefoot, Temple became known as "Progressive Temple" and the "Prairie Queen."

The Missouri, Kansas, & Texas Railroad built a line through Temple in 1882. Activity really began humming in Temple by the turn of the century. Santa Fe's new brick depot anchored the downtown section when it was built in 1910, and soon commercial buildings rose from the prairie, homes became neighborhoods, and those infamous dirt streets still fingered outward in every direction. A genuine downtown began to emerge with banks, stores, hotels, government buildings, and public spaces, including the Carnegie Library. The wooden buildings constructed in the previous century gave way to multi-story commercial brick structures. One of the earliest in downtown was the GHB Building, known as the Cotton Exchange Saloon, built in 1894 but recently home to Cotton Exchange Antiques. Cotton, an agricultural staple in Central Texas for decades, was bought and sold from horse-drawn wagons on the public square. Downtown swarmed like a beehive on cotton-trading days.

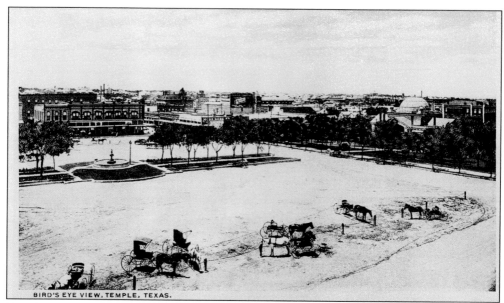

BIRD'S-EYE VIEW. This downtown overview shows the new fountain, built for aesthetics as well as for watering horses, and the domed Carnegie Library on the right. W. Goodrich Jones and the Temple Book Concern distributed this postcard. Jones was a one-man chamber of commerce, promoting tree planting, parks, and other beautification projects. He sold and planted trees for 50¢ apiece. (Courtesy Railroad and Heritage Museum.)

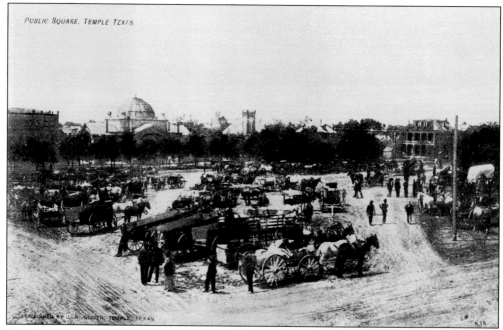

THE PUBLIC SQUARE. This view of downtown Temple again shows the Carnegie Library, which dominated the horizon in that day. Horse-drawn wagons clogged the square on cotton-trading days. "King Cotton" was the backbone of Bell County agriculture for many decades. (Published by J.R. Oliver.)

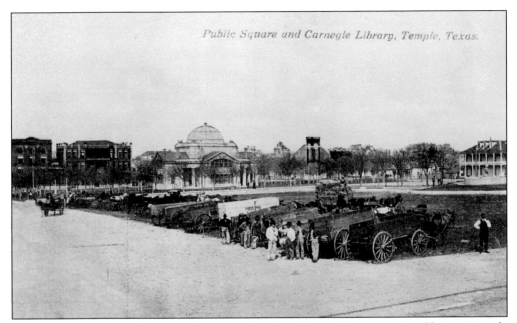

Public Square and Carnegie Library, Temple, Texas.

PUBLIC SQUARE AND CARNEGIE LIBRARY. Another view of the square in old-time Temple reveals new construction in town and again captures the horses and wagons gathering to sell cotton. The Carnegie Library never failed to enhance the skyline. (Courtesy Railroad and Heritage Museum.)

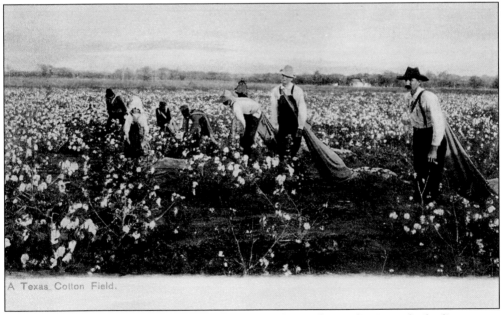

A Texas Cotton Field.

A TEXAS COTTON FIELD. Thousands of scenes similar to this made Texas the leading cotton producer in the United States by the early 20th century. Texas produced more than 2.6 million bales (500 pounds each) annually in its rich, alluvial lands. Enormous crops found their way to New England and Europe, yielding approximately $116 million a year. Over 600,000 tons of cottonseed kept innumerable oil mills busy. (Courtesy Raphael Tuck & Sons.)

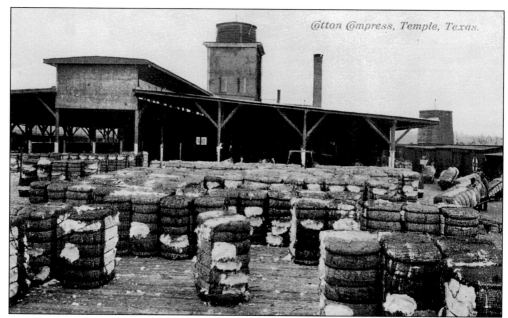

COTTON COMPRESS. Temple's cotton compress compacted bales of cotton for more efficient transportation to market. On a typical Saturday in the fall, farmers parked wagonloads of picked cotton around the corner of Avenue A and Main Street for an outdoor cotton market. They bargained with buyers for the best prices, which ranged from 5¢ to 7¢ per pound. (Courtesy Railroad and Heritage Museum.)

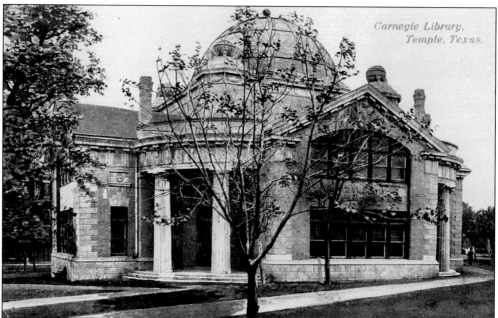

CARNEGIE LIBRARY. Pictured here is Temple's landmark Carnegie Library. Elegant inside and out, the library held its formal opening on February 4, 1904. The presence of such a civilized civic resource helped build the town's reputation as "Progressive Temple." (Courtesy Railroad and Heritage Museum.)

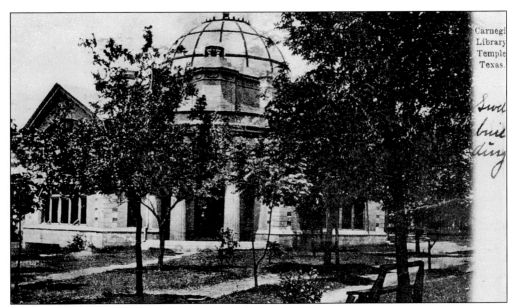

CARNEGIE LIBRARY, 1907. The library was Temple's fist matching funds project, financed jointly by Gilded Age industrialist and philanthropist Andrew Carnegie and local citizens. Mrs. W.S. Banks headed the fund drive. The library served the young city well. As the sender of this postcard wrote to her recipient, it was a "swell building."

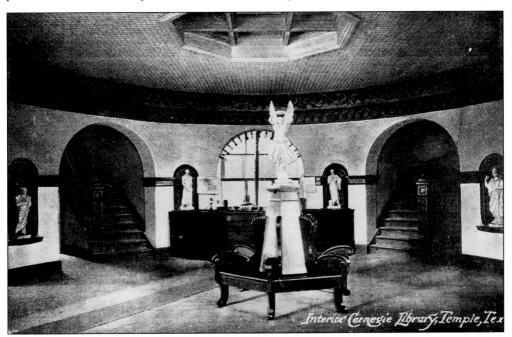

INTERIOR, CARNEGIE LIBRARY. The Carnegie Library was a robust part of Temple's culture until the building was destroyed by fire on September 22, 1918. The rich Victorian styling and the statuary in the library's rotunda were well worth noticing. It truly was a "swell building," and as the writer of this postcard noted, "I don't see this every day." (Courtesy Railroad and Heritage Museum.)

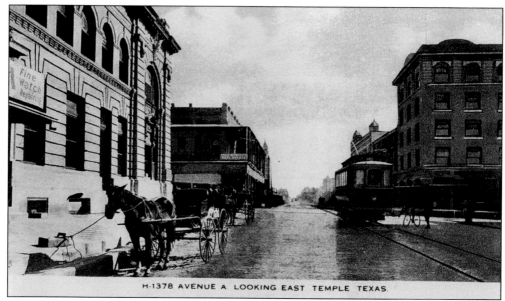

H·1378 AVENUE A LOOKING EAST TEMPLE TEXAS.

AVENUE A LOOKING EAST, JULY 1917. As Temple matured, the 20th century dawned. Commercial buildings rose from the prairie and real neighborhoods of homes grew, but nonetheless those dirt streets still crisscrossed town for the first quarter of the 1900s. Downtown featured banks, stores, hotels, government buildings, offices, and public spaces. (Published by Fred Harvey.)

SANTA FE PARK, DEPOT, AND HARVEY HOUSE. Construction on Temple's Santa Fe Depot began in August 1909 and was completed January 29, 1911 at a cost of more than $200,000. The depot is classic Prairie–Beaux Arts architecture. Note the Santa Fe trademark—a cross in a circle—formed in brick by talented craftsmen. (Curt Teich; distributed by Temple Book Concern; courtesy Railroad and Heritage Museum.)

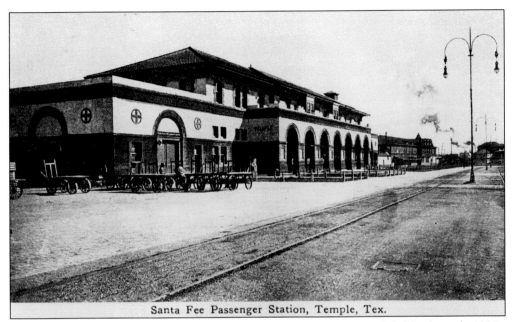

Santa Fee Passenger Station, Temple, Tex.

SANTA FE DEPOT, 1912. Santa Fe vacated the building in 1989. Amtrak left in the early 1990s, abandoning the depot. The depot was restored and reopened in July 2000. Amtrak returned with its *Texas Eagle*. Buses connect to Killeen and Fort Hood. Burlington Northern Santa Fe tracks provide transportation north of Temple, traveling south of Temple, Union Pacific. (E.C. Kropp Co., Milwaukee.)

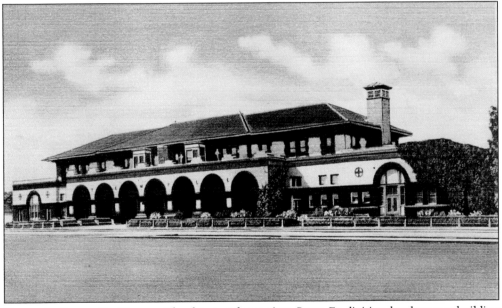

TEMPLE'S SANTA FE DEPOT. The depot and one-time Santa Fe division headquarters building is fully restored, housing the Railroad and Heritage Museum. On the grounds are static railroad displays; the Moody, Texas depot; and the WhistleStop Playground. The depot also contains a full-service Amtrak office, offering ticket sales, checked baggage, and small package express. (Curt Teich; distributed by Barton's News Agency, Temple.)

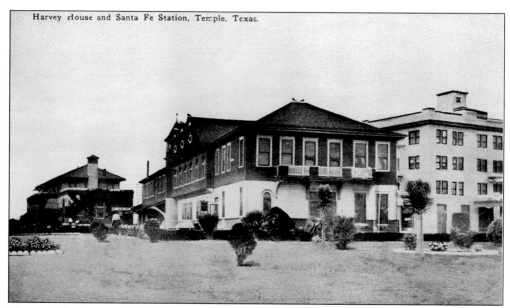

Harvey House and Santa Fe Station, Temple, Texas.

HARVEY HOUSE AND SANTA FE STATION. Fred Harvey left England at 15 for New York City, where he worked in the restaurant business. During the Civil War, Harvey switched careers, elevating ever higher in railroading. He never forgot the restaurant business, however, and surmised that railroad food needed improvement. In 1870, Harvey met Charlie Morse, president of the Atchison, Topeka & Santa Fe Railway. A new alliance was formed.

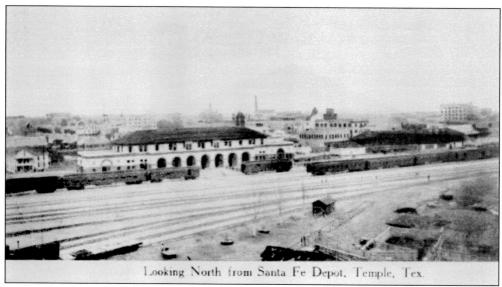

Looking North from Santa Fe Depot, Temple, Tex.

LOOKING NORTH FROM SANTA FE DEPOT. For nearly a century, Fred Harvey's company provided good food at reasonable prices for travelers in the American Southwest in clean restaurants bringing civilization and community to the West. A noteworthy fact in the history of the West is that approximately 100,000 girls signed up to work for Fred Harvey from 1901 to *c.* 1944. It is estimated that half or more of the women married and stayed out West to raise their families. By 1885, there were 17 Harvey Houses; at peak popularity, there were 84 along the Santa Fe's route. Temple's Harvey House remained open until *c.* 1923. (Published by J.R. Oliver.)

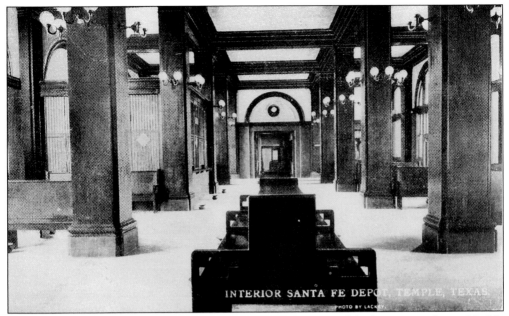

INTERIOR, SANTA FE DEPOT. This view from 1913 shows Temple's elegant new depot. Marble floors and rich, hand-crafted woodwork lend an air of grandeur. Temple's first depot was a boxcar, the second a small one-story wooden structure, and the third a two-story wooden building. A Fred Harvey House was built east of the depot in 1898 to serve traveling passengers and townspeople. (Photo by Lackey; courtesy Railroad and Heritage Museum.)

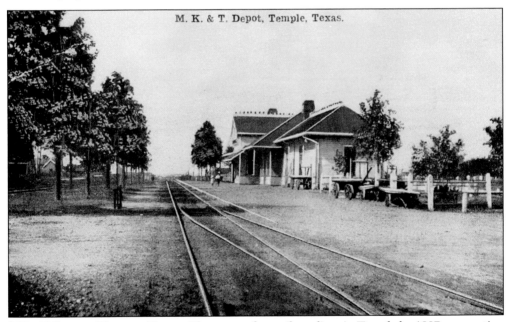

MK&T DEPOT, TEMPLE, TEXAS. There were four railway lines in Temple by 1897, connecting the city to the rest of the state: the main line and the San Angelo branch of the Santa Fe, plus the main line and the Belton branch of the Missouri, Kansas & Texas Railroad. Each day, 23 trains carried passengers to and from the city. (Courtesy Railroad and Heritage Museum.)

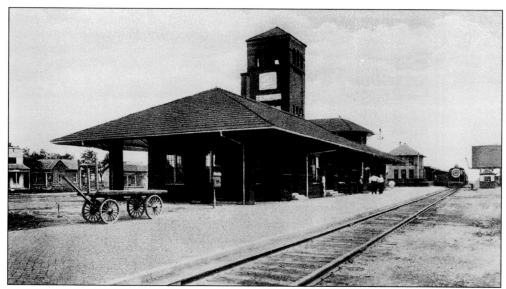

MK&T DEPOT. The Katy Depot, at Fourteenth Street and Central Avenue, belongs to Temple's Railroad and Heritage Museum, where their archives are housed. The City acquired the structure but not the land. Therefore, Temple could be forced to move the depot if owner Union Pacific dictates. Thankfully, the depot will not be torn down. (Curt Teich; distributed by Temple Book Concern; courtesy Railroad and Heritage Museum.)

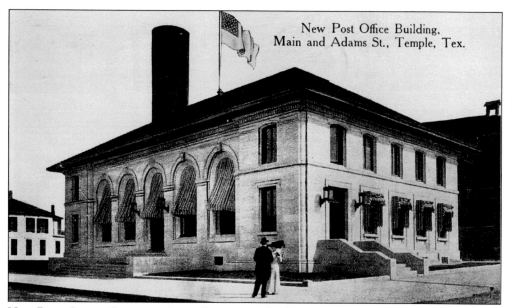

NEW POST OFFICE BUILDING. Located at Main and Adams, Temple's "new" 1912 Renaissance-style post office served the postal system until the 1960s, when a modern downtown mail facility was constructed. Declared surplus property by the government, this building was donated to the city to serve as a library. When the library outgrew this site, it became home to several programs of Temple College. (Published by J.B. Oliver; courtesy Railroad and Heritage Museum.)

CITY PUMPING STATION. By 1900, a city sewer system was installed, and in 1905 an artificial-gas plant powered the city's gaslights. In that same year, the interurban trolley system between Temple and Belton began operating. "Progressive Temple" was on her way to becoming an important city for commerce and railroads. (E.C. Kropp Co., Milwaukee; courtesy Railroad and Heritage Museum.)

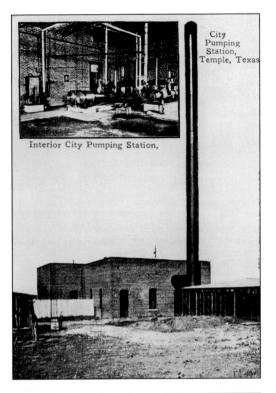

City Pumping Station, Temple, Texas

Interior City Pumping Station,

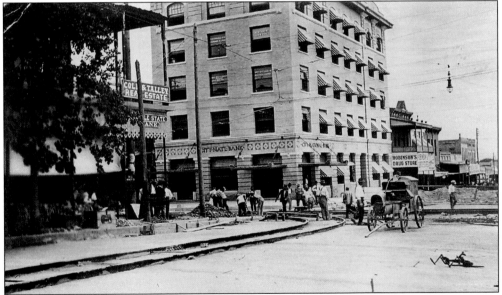

PROGRESS CONTINUES. Also in 1905, Temple Traction Company began running the interurban trolley between Temple and Belton. Workmen are seen here laying trolley tracks. By 1908, Temple boasted 2 cotton oil mills, 2 lumber planing mills, 22 physicians, 6 dentists, 8 druggists, 12 real estate men, 6 restaurants—Chinaman Ling's being the favorite—3 hotels, 12 lawyers, 6 cotton gins, 4 wholesale grocers, 12 churches, several lumber yards, 3 cotton compresses, 1 race track, and 1 fairground just north of Lake Polk.

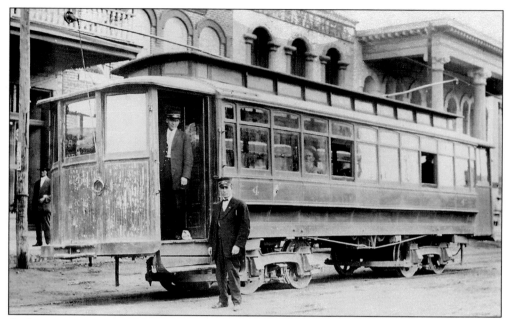

A DAY'S WORK. Motorman Charles Chalmers Jr. is seen standing in front of this Temple Traction Company car, *c.* 1925. He would tell about the day he picked up passengers at Peppers Creek between Temple and Belton. A flock of birds flew up in front of the trolley's windshield, splattering it with droppings. Chalmers turned to his passengers and said, "Aren't you glad that cows don't fly!" (Courtesy Railroad and Heritage Museum.)

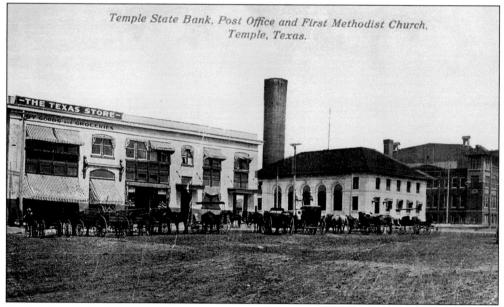

TEMPLE STATE BANK, POST OFFICE, AND METHODIST CHURCH. This 1918 view looks north and east from what is today the Municipal Building. One noteworthy building was the large emporium known as the Texas Store. Dirt streets and wooden sidewalk decks were the norm, and rats thrived beneath these wood plank sidewalks. The city once paid a bounty for dead rats. Over time, asphalt and concrete replaced wooden sidewalks to alleviate the problem.

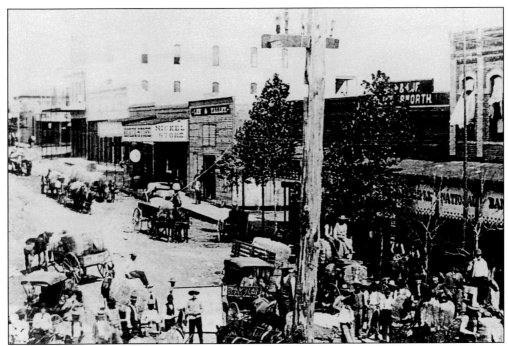

Shopping Day. Pictured here is the east side of South Main from Avenue A, looking in a northeast direction. The town square is to the left, out of view, and Temple National Bank is on the right. (Courtesy Railroad and Heritage Museum.)

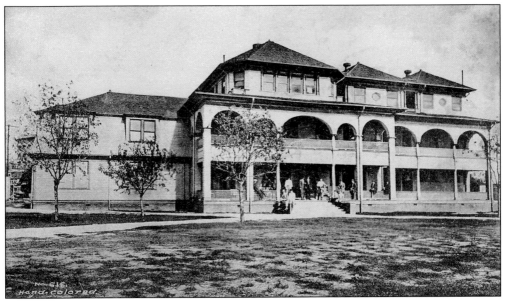

YMCA (1914). The Railroad Young Men's Christian Association (YMCA), which cost $12,000 including furnishings, opened August 1, 1899. It featured 24 bedrooms, tubs and showers, a large gym with instructors, bowling alleys, classrooms, a reading room, a library that opened with 500 volumes, a parlor, social rooms, a kitchen, and a meeting room. Mrs. J. Baldwin Nunnally donated a 75- by 25-foot indoor swimming pool in 1920 known as the Nunnally Natatorium.

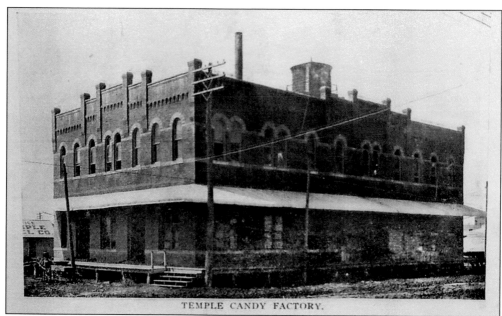

TEMPLE CANDY FACTORY.

TEMPLE CANDY FACTORY (EARLY 1900s). Temple was already a bustling young city during its horse and buggy and dirt street days. Red brick paving began in 1910 for downtown streets, fostering the "Progressive Temple" slogan. Other notable businesses of the period included Temple Electric Light Co., Pasteur Water Filter Co., Prairie Queen Laundry, Square Saloon (on the square), J.W. Kyle & Son Furniture, and Cheeves Bros. (Courtesy Helen Vaughan.)

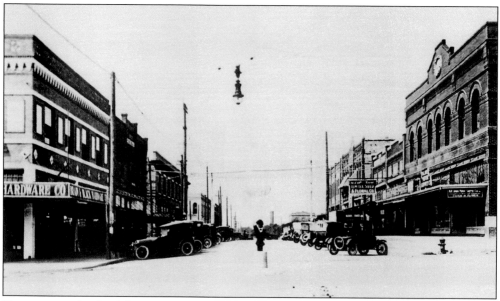

DOWNTOWN. On the right is Motor Supply and Temple Seed & Floral Co. To the left is Brady & Black Hardware at the corner of Central and South Second Street. Duncan A. Black (1850–1941) from Newton County, Mississippi, was one of the partners in the business. (Courtesy Temple Public Library.)

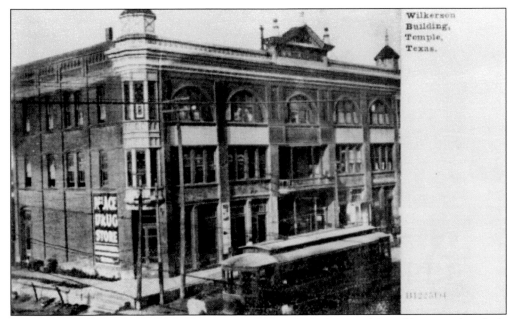

WILKERSON BUILDING. The turn of the 20th century was Temple's golden age, but little remains of those cupola-crowned buildings trimmed with gingerbread and wrought-iron grillwork. The once treeless prairie was becoming "A City of Trees." The description applied to residential areas and also to downtown street corners where hackberry trees had been planted during beautification efforts in the 1890s. (H.G. Zimmerman & Co., Chicago; courtesy Brenda McGuire.)

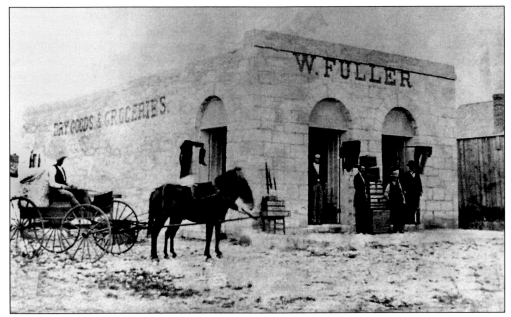

THE BEGINNING OF COMMERCE. The William Fuller Store, pictured here, is the first mercantile establishment in Temple. He began the business in a tent and later built this stone building at the corner of Avenue D and Twelfth Street. (Courtesy J.H. Roeder Collection.)

31

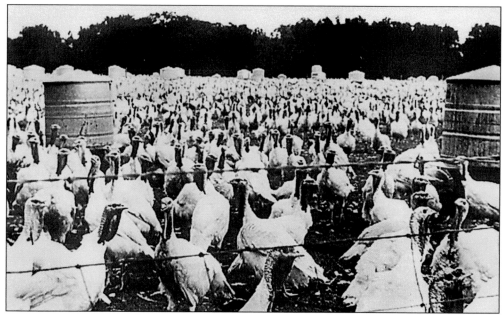

GOBBLE, GOBBLE, GOBBLE. In the earliest periods of settlement in Bell county, prior to the establishment of Temple, there had been a belief that the soil was not fit for agriculture. Therefore, in the first half of the 1800s this area was livestock–oriented with cattle, of course, but also with critters such as turkeys and chickens. Western Hatcheries still has a large operation in Temple.

Three

PROGRESSIVE TEMPLE

Temple was the division point of three railroad routes: north to Fort Worth, south to Galveston, and west to Santa Fe, New Mexico. The Atchison, Topeka, and Santa Fe purchased the Gulf, Colorado & Santa Fe (which had founded Temple) in 1896, and Temple became the railroad's Southern Division Headquarters. Chief Engineer C.F.W. Felt petitioned the Galveston headquarters in 1908 to construct a depot in Temple at an estimated cost of $65,264. Award-winning Chicago architect Jarvis Hunt was retained to design the new depot. Construction began in August of 1909 and was completed January 29, 1911, with final costs exceeding $200,000. The depot is featured in Jay C. Henry's Architecture in Texas: 1895–1945 (University of Texas Press, 1993).

An interurban trolley line to the county seat in Belton enhanced Temple's progressive stature immensely. Midway, Texas, centrally located between Belton and Temple in central Bell County, was settled in the mid-1800s and in the 1850s had a combination church and school. The Rock Church School had 68 pupils and one teacher by 1903. Midway had two businesses and 40 inhabitants in 1940, and in 1947 it boasted a store and a gas station. Population increased dramatically by 1974 with 122 inhabitants.

Churches and schools tamed Temple's wildness, creating a civilized place for families. Fine hotels served the public, either those who were passing through by train or folks coming to Temple on business.

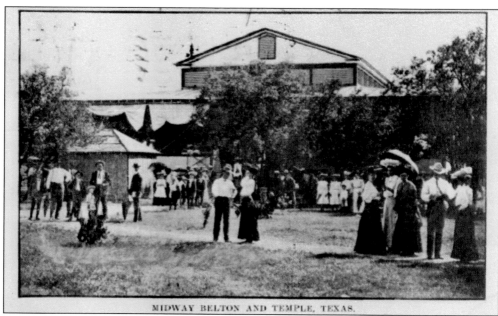

MIDWAY, BELTON, AND TEMPLE, TEXAS. This 1921-era photo postcard shows a group of folks gathered at the Interurban Station in Midway, which was the site for the maintenance facilities for the Interurban Trolley Line. By 1988, Midway had been absorbed into Temple and was no longer listed separately on county maps. (Courtesy Brenda McGuire.)

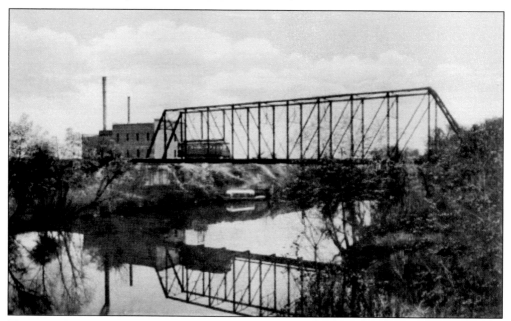

TROLLEY BRIDGE. Part of Temple's history is buried in the asphalt of the city's streets—it's the tracks of the Temple-Belton Interurban Trolley. Trolleys crossed the Leon River near the Temple Water Works Power House southwest of Temple from 1904 into the 1920s. This was only the third trolley system in Texas. The inaugural trip took place November 3, 1904, carrying invited guests. (Curt Teich; courtesy Brenda McGuire.)

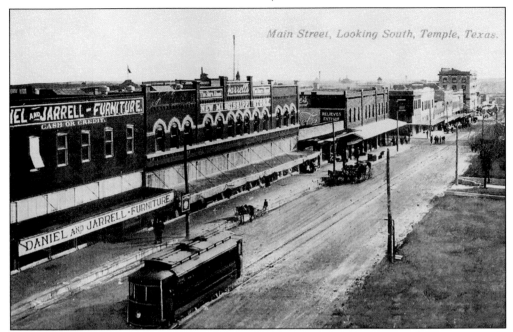

Main Street, Looking South, Temple, Texas.

MAIN STREET, LOOKING SOUTH. Note the trolley rambling north on Main Street. In the era when this picture was made, the new Mississippi Store (second establishment from the left in this scene) was having a sale. Ladies' $5 jackets were marked down to a steal price of $3.45. The Mississippi Store also carried assorted buttonhooks for ladies to fasten their high-topped shoes, *c.* 1907. (Courtesy Brenda McGuire.)

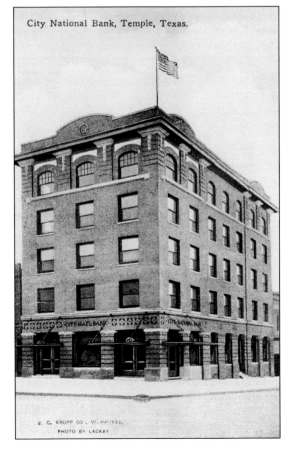

City National Bank, Temple, Texas.

CITY NATIONAL BANK. Located on South Main Street, Temple's City National Bank boasted a spacious, beautiful, and modern interior. It featured expensive marble floors and walls, with fanciful wrought-iron grillwork. Their location was two doors north of W. Goodrich Jones' Temple Book Concern. (E.C. Kropp, Co., Milwaukee; courtesy Brenda McGuire.)

35

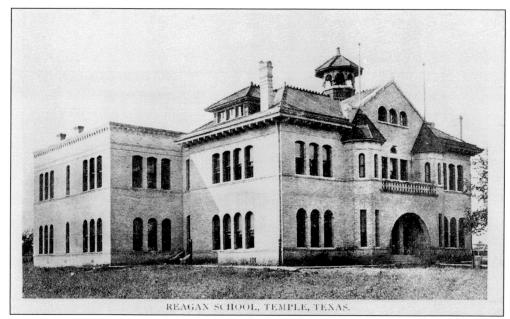

REAGAN SCHOOL, TEMPLE, TEXAS.

OLD REAGAN SCHOOL, 1910. The first six rooms were constructed in 1896. By the 1920s, more space was needed and so additions were made to the school. The old school has served faithfully through the years. What Reagan student of the 1960s can forget Mr. Lambert's store across the street? When the bell sounded dismissal, kids dashed over to spend nickels and dimes on sweet treats after school. (Courtesy Helen Vaughan.)

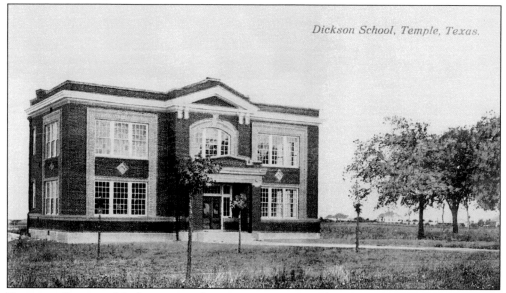

Dickson School, Temple, Texas.

DICKSON SCHOOL. No longer an elementary campus, Dickson FOCUS Center on South 33rd Street now houses TISD's Project FOCUS. This program serves entire families—from infants to adults. An array of academic and enrichment activities for children are offered, such as music lessons, art classes, dance classes, math clubs, science clubs, and individual tutoring. It also offers literacy training, GED preparation, and special interest classes for adults. (Courtesy Brenda McGuire.)

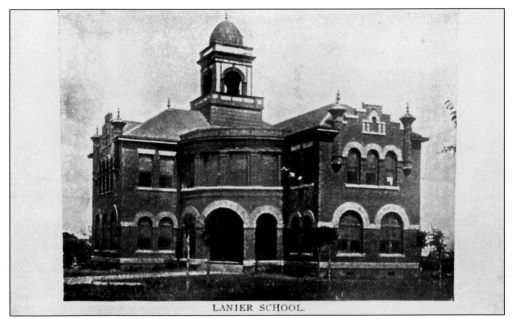

LANIER SCHOOL.

OLD LANIER SCHOOL (VERY EARLY 1900s). In 1928, a young organization called the PTA organized an effort to replace the structurally unsafe and bat-infested old Lanier and Vandiver Elementary Schools with new facilities. Old Vandiver was built in 1896 for $6,500, while Lanier was constructed in 1907. Both schools were torn down in 1928, replaced with their new namesakes. (Courtesy Helen Vaughan.)

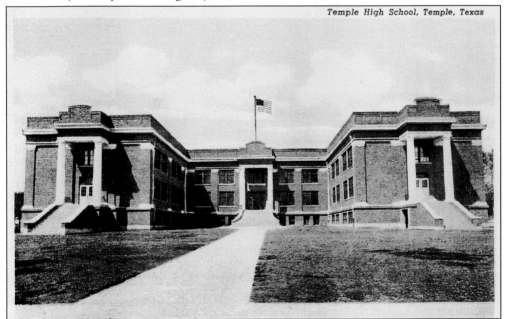

Temple High School, Temple, Texas

TEMPLE HIGH SCHOOL (1947). The core of the building was constructed around 1912 on a site near today's Central Fire Station on North Third Street. Two wings (seen here) were later added in 1926. This facility was torn down in 1965, replaced by the current high school. The gym of the old THS remains in use as part of the city recreation department. (Curt Teich.)

37

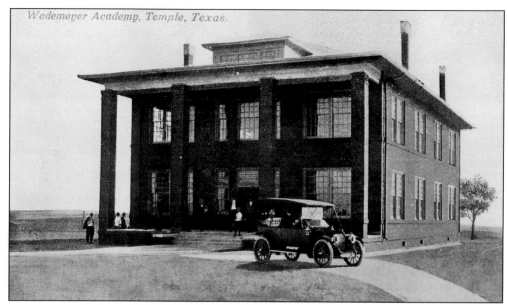

Wedemeyer Academy, Temple, Texas.

WEDEMEYER ACADEMY (1900). A former lecturer at Baylor College in Independence, C.H. Wedemeyer in the 1890s founded a school for young men, between South Forty-fifth and Forty-seventh on Avenue J. Upon coming to Bell County in 1888, Wedemeyer first established a school at Belton, later moving to Temple where he built his academy. It served as apartments during World War II and was demolished in the 1960s. (Courtesy Brenda McGuire.)

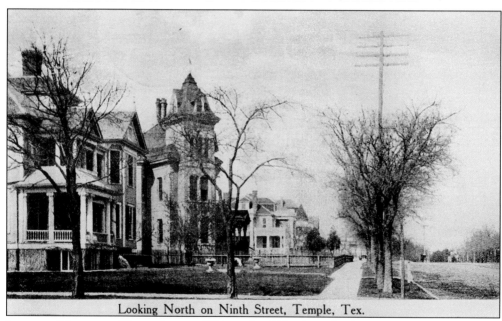

Looking North on Ninth Street, Temple, Tex.

LOOKING NORTH ON NINTH STREET. Visitors should begin at the downtown Visitor Center for a copy of the *Historic Temple Brochure*. It provides direction to 10 beautiful homes on the Historic Driving Tour including the Gov. James E. Ferguson home, which now houses the Stitch-in-Time Quilt Shop. North Ninth Street and the surrounding neighborhoods feature shady tree-lined streets and magnificent old homes. (Published by J.R. Oliver.)

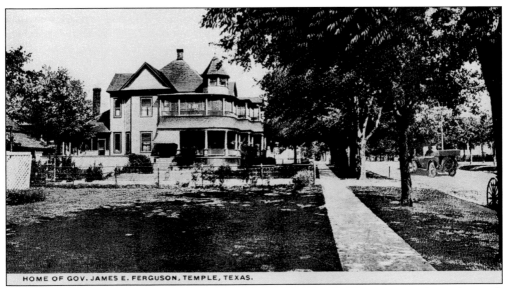

HOME OF GOV. JAMES E. FERGUSON, TEMPLE, TEXAS.

HOME OF GOV. JAMES E. FERGUSON. Jim and Miriam Ferguson were an unusual couple—each served as governor of Texas. He involved himself in banking and newspapering, while she, a "well-to-do country girl," was educated and well read. They built this house at Seventh and French Street in 1906 for $4,800, living here with their two girls until 1915 and again from 1917 to 1925, when they moved to Austin. (Curt Teich; distributed by Temple Book Concern.)

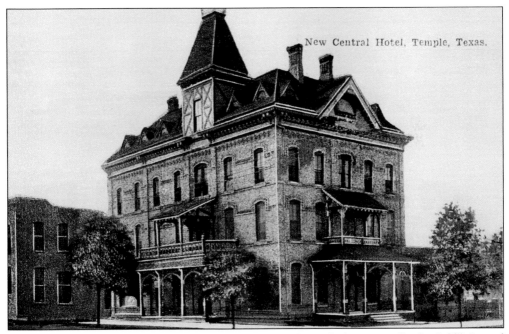

New Central Hotel, Temple, Texas.

NEW CENTRAL HOUSE. Described as the "new" Central Hotel, this is actually the "old" Central Hotel. Located on the south corner of Third Street and Avenue A, the hotel was later remodeled, removing the turrets and creating a boxier, more modern facade. Situated only a block from the train depot, the hotel catered primarily to rail passengers. It was torn down in the 1950s to make way for a city parking lot.

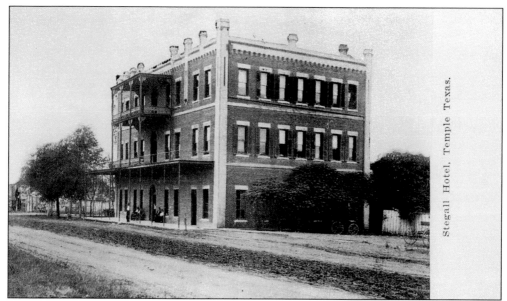

Stegall Hotel, Temple Texas.

THE STEGALL HOTEL. Located on North Third Street between Central and Adams, the Stegall was convenient to the train depot and catered to rail passengers and traveling salesmen. Built originally as a two-story structure by Capt. and Mrs. W.H. Stegall, a third story was added to the hotel in 1895. A fourth story was completed, *c.* 1910, making the Stegall Temple's first four-story building. (Kansas City Post Card Co.)

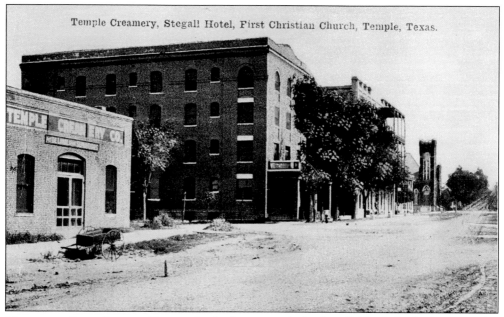

Temple Creamery, Stegall Hotel, First Christian Church, Temple, Texas.

NORTH ON FIFTH STREET. Here again, in the center, is the Stegall Hotel. In the foreground is Temple Creamery, and beyond the hotel the old First Christian Church is visible. Today, this area is just west of the Temple *Telegram* building. (Courtesy Temple Public Library.)

DOERING HOTEL. Temple's population averaged around 15,000 during the 1920s, yet the skyline featured three "skyscrapers." All went up during the nationwide construction boom preceding the 1929 stock market crash. These structures included the Kyle Hotel, the Professional Building (later the SPJST Building and the Cordova Building), and the Doering Hotel (later known as the Hawn).

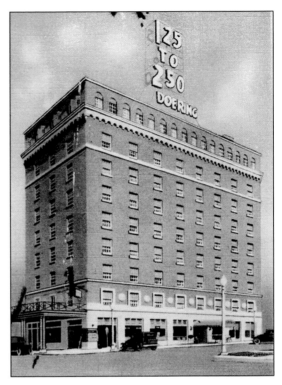

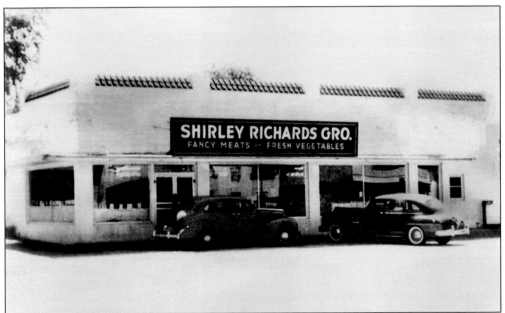

IT ISN'T ALBERTSON'S. Before there were supermarkets, there were neighborhood grocery stores such as Shirley Richards' Grocery located on East Adams Avenue. These were the days when they scattered sawdust on the floor and then swept with a push broom to clean up. Robert McFarland later operated the store when Richards went into the insurance business. (Courtesy J.H. Roeder Collection.)

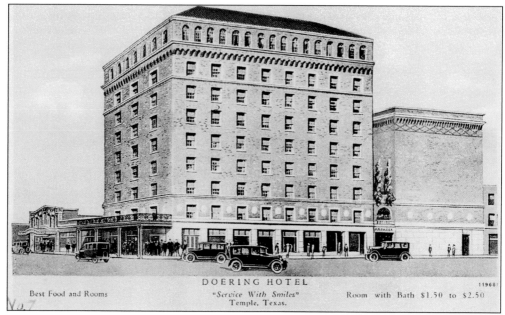

DOERING HOTEL
Best Food and Rooms
"Service With Smiles"
Temple, Texas.
Room with Bath $1.50 to $2.50

DOERING HOTEL, C. 1928, STILL GIVING "SERVICE WITH SMILES." The hotel featured a coffee shop, restaurant, and a large ballroom. They advertised the "Best Food and Rooms." The rate for a room with a bath ranged from $1.50 to $2.50. (Allis Press, Kansas City, Missouri.)

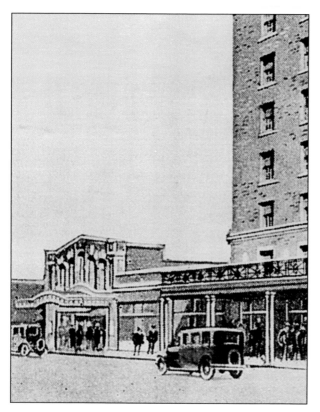

THE ARCADIA THEATRE FACADE (FACING SOUTH). This detailed view shows the Doering Hotel on the right. The theatre, on the left, is an L-shaped building that wraps around two sides of the Doering Hotel. The facade and lobby run south to north, extending across the rear width of the theatre itself. The seating area runs west to east with the stage and screen on the eastern end.

DOERING HOTEL, EASTERN FACADES. This side of the Doering includes an entry into the middle of the Arcadia Theatre lobby; the front entry is to the west of the Doering and faces south. It was an ingenious arrangement to provide access to the Arcadia from two sides of the block. Anyone who frequented the Arcadia in its heyday should remember longtime manager Tillman Bond, who also managed the Texas Theatre.

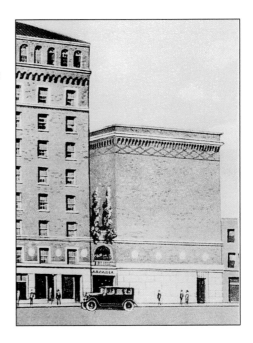

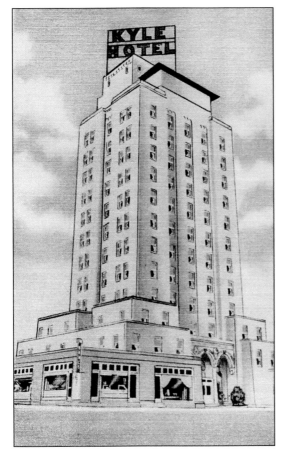

KYLE HOTEL, TEMPLE, TEXAS. With its 1929 opening, the Kyle Hotel brought something new to Temple—the word "mezzanine," or that unnumbered floor overlooking its beautiful lobby. This tall hotel also attracted a "human fly" daredevil, who drank a Coca-Cola halfway up the side of the building. Dr. A.C. Scott, who wanted a place for outpatients and visitors to stay while at Scott and White Hospital, conceived of the hotel.

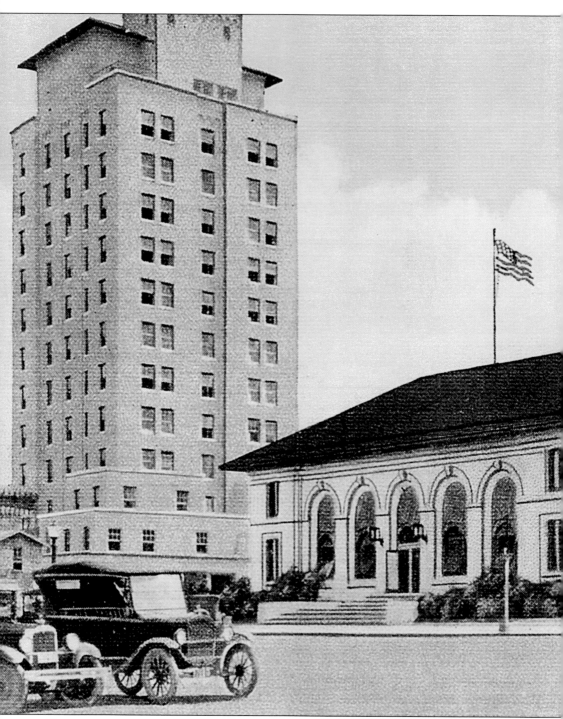

KYLE HOTEL, POST OFFICE, AND FIRST METHODIST CHURCH. This view of Temple looks much the same today as it did during the late 1920s. In the beginning, the Kyle had 10 bellhops, a day clerk, a night clerk, and a day and a night switchboard operator, all working 12-hour shifts. To make sure the hotel was profitable, Mrs. Fred Stalkup, auditor, went outside at night and

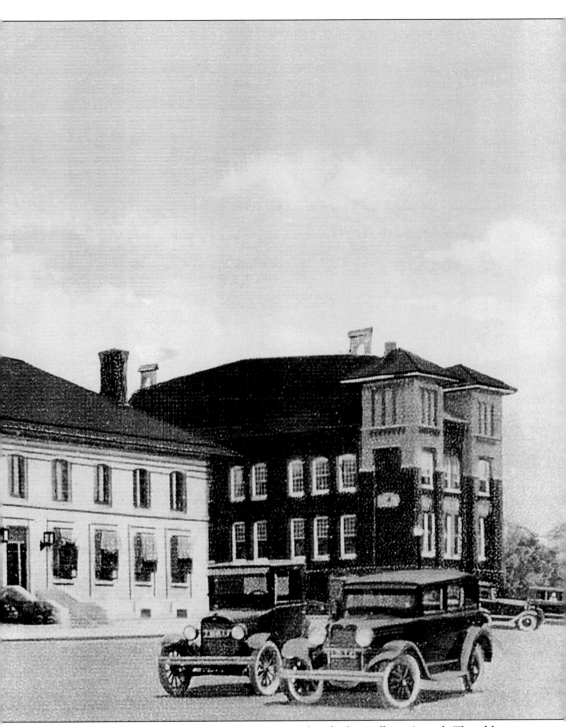

counted the lighted windows to make sure every resident had actually registered. The old post office now belongs to Temple College and remains a downtown landmark. The First United Methodist Church still occupies its corner, and has been enlarged over the years to make room for its growing congregation. (Curt Teich.)

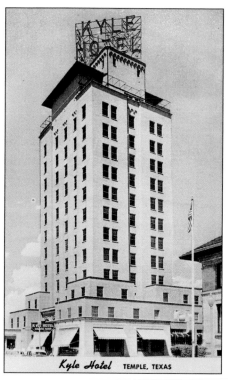

Kyle Hotel TEMPLE, TEXAS

TEMPLE'S FINEST HOTEL. This late 1950s or early 1960s view of the Kyle shows the coffee shop to the right (ground floor) and a florist shop on the left. Besides its 125 rooms and baths, the Kyle housed beauty and barbershops as well as a dry cleaner. All the city's civic clubs met in the hotel's facilities. For a time, KYLE-FM broadcasted classical and easy listening music from the top floor. Famous guests included Roy Rogers, Gene Autry, and Lawrence Welk. It was air-conditioned all year and had a TV in every room. Louis Marchette was manager for many years. (PlastiChrome by Colourpicture Publishers, Inc., Boston.)

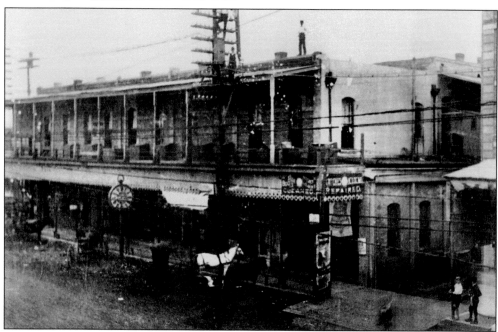

THE WAY WE WERE. This view of the "business district" shows several of the shops that were in Temple between 1890 and 1900. The round sign on the building near the center says "Watches and Clocks Repaired." If the young men atop the utility pole are not careful, *they* may soon be in need of some repair. Notice too the dirt street. (Courtesy J.H. Roeder Collection.)

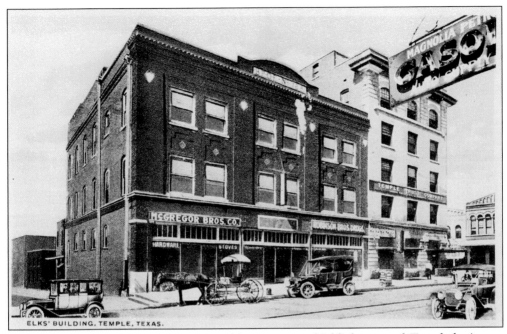

THE ELKS BUILDING, TEMPLE, TEXAS. This street scene highlights several Temple businesses of the era, including McGregor Bros. Hardware, Robinson Bros. Drugs, and Temple Trust Company. (Curt Teich; distributed by Temple Book Concern; courtesy Brenda McGuire.)

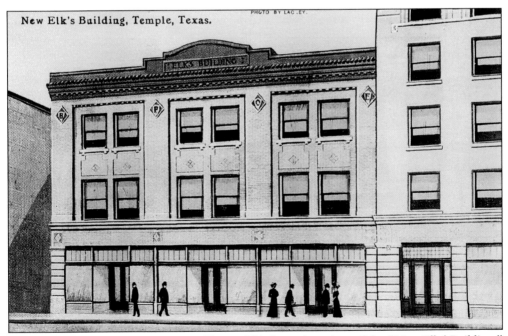

THE NEW ELKS BUILDING, TEMPLE, TEXAS. This is another view of the "New Elks' Building." They appear to be the same structure. (Photo by Lackey.)

47

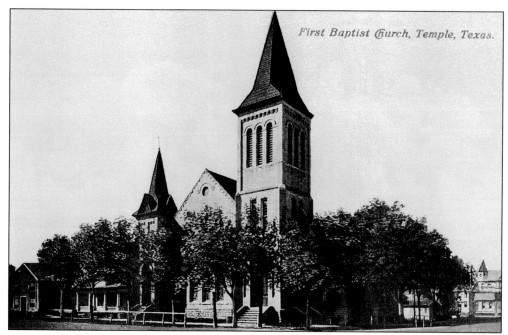

First Baptist Church, Temple, Texas.

FIRST BAPTIST CHURCH, C. 1910. In 1882, a tornado demolished the Birdsdale Baptist Church on Lake Polk west of Temple. The members, pastored by George W. Green, decided to cast their lot with the new town, buying property in downtown Temple (on the corner of Main and Barton, across from the future site of the Kyle Hotel) and constructed the First Baptist Church. They used lumber salvaged from the Birdsdale Building. They quickly outgrew that original building by 1895 and constructed the church pictured here at the same location on Main and Barton. However, this building burned on March 6, 1938. (Courtesy Brenda McGuire.)

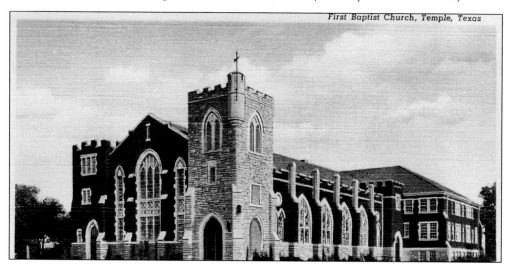

First Baptist Church, Temple, Texas

THE NEW FIRST BAPTIST CHURCH. Just northeast of the burned church is the new building in use today—in a greatly expanded form. Presbyterians constructed Temple's first church in the white community in 1881, followed by Baptists and Methodists. Early church buildings in the "colored" community included Eighth Street Baptist Church (T.E. George, pastor), Wayman Chapel, and the A.M.E. Church, one of the first to organize in Temple. (Curt Teich.)

Catholic Sisters Convent. At Fifth Street and Avenue F, the wooden structure served as the convent's kitchen and dining hall as well as connecting the south and north buildings (the back of the north building is seen here). Dr. A.C. Scott and Dr. R.R. White bought this property in 1905 and converted it into Temple Sanitarium. (Courtesy Railroad and Heritage Museum.)

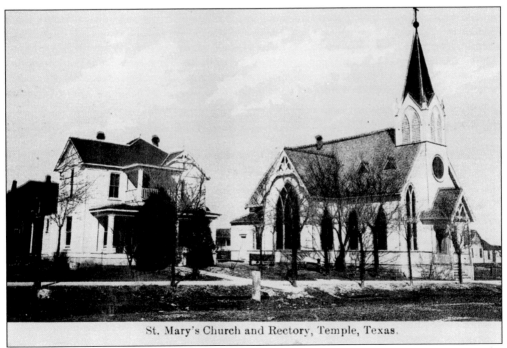

St. Mary's Church and Rectory, Temple, Texas.

St. Mary's Catholic Church and Rectory. The rectory was completed in 1894, the church in 1895 (near Seventh and Avenue G). This site was sold to Scott and White Hospital in the late 1920s, and new church property was purchased on South Seventh Street. Their program includes St. Mary's School, which has purchased and is renovating the old Reagan Elementary. This will expand St. Mary's campus while preserving historic Reagan School. (Courtesy Railroad and Heritage Museum.)

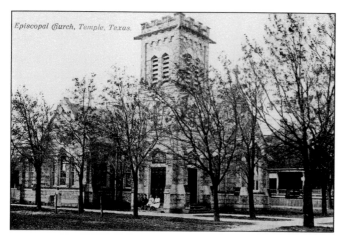

Episcopal Church, Temple, Texas.

EPISCOPAL CHURCH, C. 1905. Christ Church in Temple was established in 1883, two years after the city's founding. The group's first services were in facilities owned by the South Main Street German Church. They constructed a wood-frame building in 1901 that was later moved to the present church site at Main and Calhoun. The congregation was a self-supporting and independent Episcopal parish by 1902. Soon, members began plans for a new building. Construction on the present English Gothic building began in 1904 and was completed in 1905. Since 1889, 14 priests have served as rector. A parish hall was built in 1942, and the parish acquired property that now includes the entire block. The McGowen-Stephens School serves the community with a pre-school, an after-school program, and a summer day-care project. (Courtesy Railroad and Heritage Museum.)

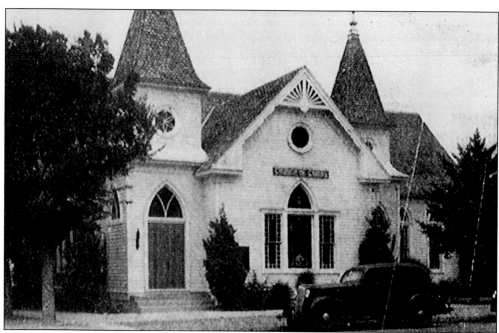

CHURCH OF CHRIST. In the summer of 1908, the Church of Christ met in the home of Mrs. George Christian with around 10 members. For several months they met in members' homes, until a meeting place was secured at the Odd Fellows' Hall. The church began meeting in the old Macabee Hall in 1912 and then in the Carnegie Library Building. In 1913, the congregation purchased a small building from the Baptists at the corner of Avenue G and Seventh Street (seen here). This location was on the same block with Temple Sanitarium next door to the Main Clinic Building (which had been Woodson's Eye, Ear, Nose, and Throat Hospital). This neighborly arrangement continued until both Scott and White and the church moved in 1963.

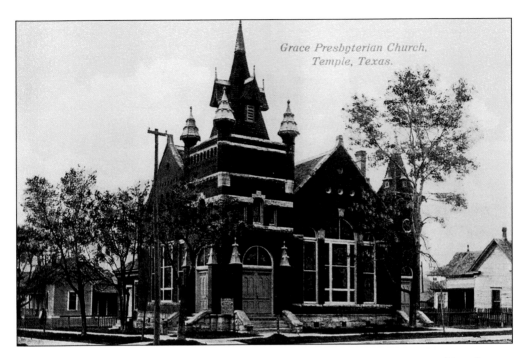

Grace Presbyterian Church, Temple, Texas.

GRACE PRESBYTERIAN CHURCH. Nearly 110 years ago, Temple was just 15 years old, and Grace Presbyterian Church was organized with 18 members. For seven years the church met in a rented hall; during the summer they used a tabernacle at Eighth Street and Avenue A. They laid the cornerstone in 1899 of a new $500 church at Barton and Third (torn down in the 1960s). The first service in the new red brick building was on March 18, 1900. Their membership increased to 362 by 1924, when Temple's population was nearing 15,000. The church broke ground for a new building costing $180,000 at Fifty-seventh and Avenue Z in 1965. The church celebrated its centennial in 1993. (Courtesy Railroad and Heritage Museum.)

FIRST LUTHERAN CHURCH. This Lutheran congregation (Evangelical) was another of Temple's "refugees" during the city's west and southward expansion during the 1960s. It moved to the corner of South Thirty-first and Adams Avenue to be near areas of growth. (Courtesy J.H. Roeder Collection.)

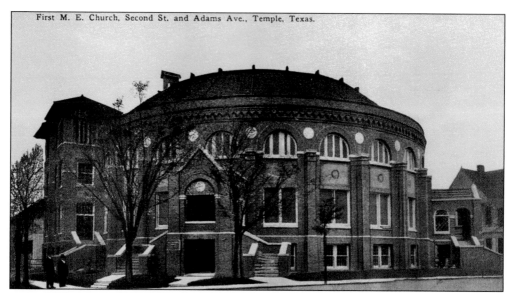

FIRST M.E. CHURCH, c. 1904. The Methodists came to town in 1882 when their congregation in the Double File community chose to disband and move to Temple. They constructed a multi-turreted wood-frame building at Second Street and Adams Avenue. It served well until fire destroyed it around 1910. They then erected the church building seen here. (Published by C.L. Reynolds, The Rexall Store; courtesy Brenda McGuire.)

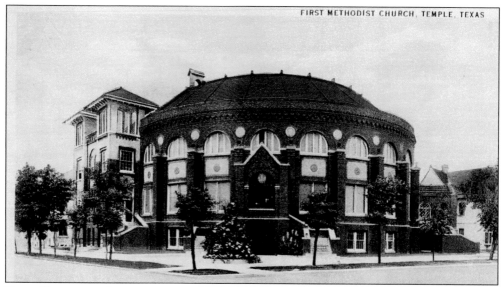

FIRST METHODIST CHURCH, c. 1919. Before the city was established, a Methodist congregation met at Double File, a rural schoolhouse on what is now Hickory Road. Approximately 32 members from Double File started First Methodist in 1882. The church bought land at Avenue B and Fourth Street in 1883. They congregated in a partially completed building by 1884, and finally, in 1891 the congregation moved to its present historic location at Second and Adams. A fire in 1911 destroyed the building, and following that the congregation employed the state's foremost architectural firm of Sanguinet & Staats of Fort Worth to design their present Romanesque revival–style building, recorded as a Texas historic landmark. (Curt Teich.)

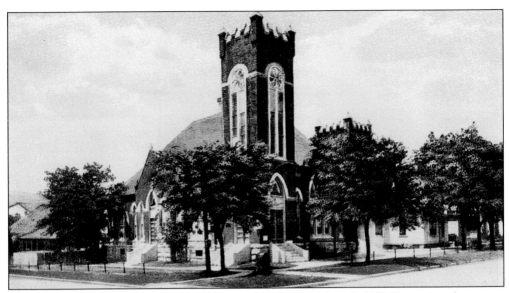

FIRST CHRISTIAN CHURCH, C. 1924. Now located at 300 North Fifth Street (on the corner of North Fifth and Calhoun), this church began under a tent in 1888. Within a year, church members bought a site between Central Avenue and Avenue A and called their first minister. By 1903, they moved to a new building and added an educational annex in 1914 at Third and Adams (now a Jack-in-the-Box). The existing building was built in 1948 and was remodeled in 1980. (Curt Teich; courtesy Railroad and Heritage Museum.)

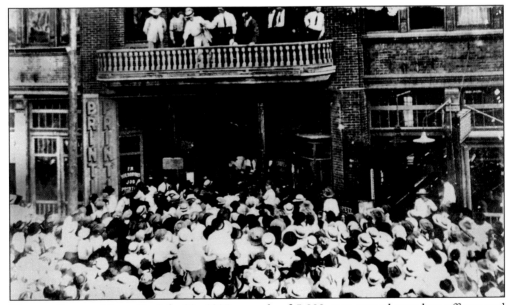

TEMPLE LYNCH MOB. On July 30, 1915, a mob of 5,000 men surged past law officers and dragged "a negro suspect" to the public square where they shot and killed him. They burned his body in a bonfire. He was suspected of beating and slashing a white man and the man's wife and three children. The suspect's guilt or innocence was never legally established. It was an ugly period and incident in Temple's history that rightfully drew harsh press coverage across the state. (Courtesy J.H. Roeder Collection.)

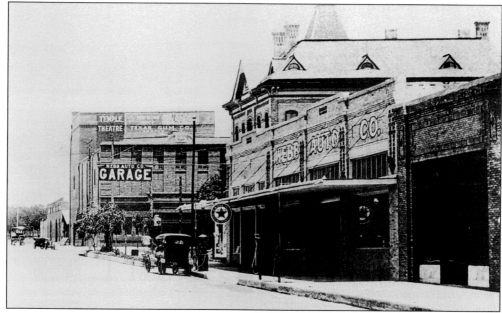

A Diversified Economy. This 1920s-era view of town indicates some of the varied businesses drawn to Temple, such as Webb Motor Co., with a Texaco sign at its service station; Webb Motor Co. Garage; Texas Gum Company; Temple Theatre; and the roof of the Central Hotel. (Courtesy J.H. Roeder Collection.)

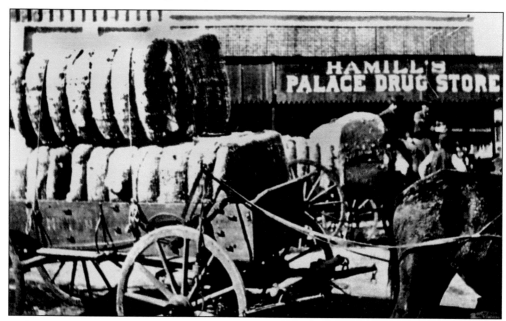

A Cure for All Your Ailments. Hamill's Palace Drug Store, with its soda fountain, notions, and patent medicines, was a popular stop when the country folk came into town on Saturdays. Mr. Hamill also served Temple as mayor in the late 1890s. "Cotton was King" on Central Texas farms (note the cotton wagon), serving as the money crop and a large part of the area's economy for many years. (Courtesy J.H. Roeder Collection.)

Four

THE PORTENT OF SANTA FE HOSPITAL

Temple had its beginning as a planned community, a railroad town on the blackland of Central Texas. The railway needed a service center to repair railroad equipment and to serve passengers and employees. By 1890, saloons with brass spittoons were making way for homes with china and crystal. Rough switchmen, engineers, and gandy dancers from the railroad were being civilized. Tanglefoot was becoming the "Prairie Queen," and another historic change was just around the curve in the tracks.

Santa Fe Hospital was established in June of 1891 to treat Temple's railroad population, and the centralized location allowed for the treating of other GC&SF employees. Today known as Scott & White Santa Fe Center, Santa Fe Hospital was on South Twenty-fifth Street. It was a 20-bed wood-frame hospital operated by the GC&SF Hospital Association, formed by the Galveston businessmen who owned the GC&SF Railway.

The new hospital attracted 27-year-old Dr. Arthur Carroll Scott from Gainesville, Texas, to serve as chief surgeon in 1892. Dr. Scott held a competitive examination for physicians applying to be house surgeon in 1895. Dr. Raleigh R. White Jr. of Cameron, Texas, scored highest, joining Dr. Scott in 1897.

With the railroad and nascent medical facilities, Temple became the largest city in Bell County at that time, reporting 7,065 residents by 1900.

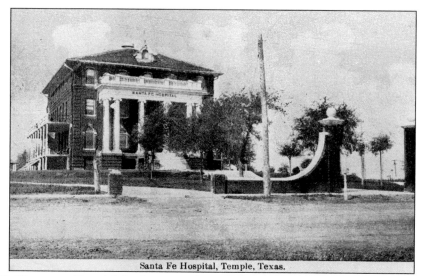

Santa Fe Hospital, Temple, Texas.

SANTA FE HOSPITAL. Temple's leaders wanted a railroad hospital. In 1889, a committee purchased 10 acres southwest of town for $1,000. The GC&SF sent Dr. C.H. Wilkinson and five nuns of the Sisters of Charity from Galveston to Temple to evaluate the need for a hospital. They came to an agreement and bought the 10 acres for $1, stipulating that if no hospital materialized they would return land ownership to Temple. The 1891 hospital was a 20-bed wood-frame building operated by the GC&SF Hospital Association with the nuns as the nursing staff. Their wages were paid to the religious order, since individual nuns had made vows of poverty. Early success for the hospital was largely due to the nursing and administrative skills of these faithful nuns. The GC&SF constructed a new red brick hospital in 1908 because of a growing clamor over the shoddiness of the wood-frame building.

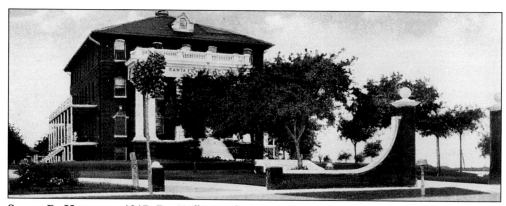

SANTA FE HOSPITAL, 1917. Dr. Wilkinson had a practice in Galveston and would not move to Temple; however, a part-time doctor proved unsatisfactory—patients were complaining—so the GC&SF Hospital Association began interviewing for a chief surgeon and a house doctor. The former would have overall charge and would treat outpatients at a downtown clinic while the house doctor would treat hospitalized patients. Dr. Arthur C. Scott of Gainesville was hired as chief surgeon. Arriving in Temple September 30, 1892, Scott went to work the next day. His first office was his room at the Central Hotel. Dr. J.L. Hanafrey joined the staff as the first house doctor, and Sister Mary Beatrice Ryan was the first druggist at Santa Fe Hospital or, as locals call it, "the Santa Fe." She also assisted Dr. Scott in 1893 with Temple's first appendectomy, then considered a major and dangerous surgery.

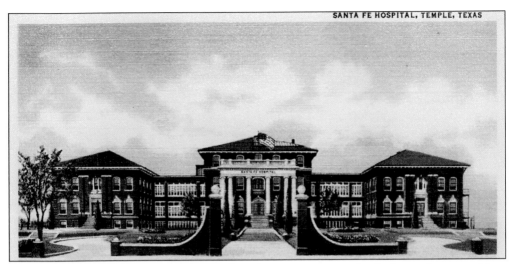

SANTA FE HOSPITAL WITH ADDITIONS. When there was a vacancy in the house doctor position, Dr. Scott prevailed on a Gainesville friend, Dr. J.M. Woodson, to fill the position on an interim basis. Woodson would later begin his own practice treating eye, ear, nose, and throat problems in Temple. Meanwhile, Dr. Scott was accepting applications for the job. In 1895, Scott held a competitive examination for the job of Santa Fe House Surgeon. Dr. Raleigh R. White Jr. of Cameron, Texas, scored highest on the test and joined Dr. Scott in 1897. The GC&SF Hospital Association maintained a downtown medical office in the City National Bank building, where doctors treated railroad employees who did not need to be hospitalized. (Curt Teich.)

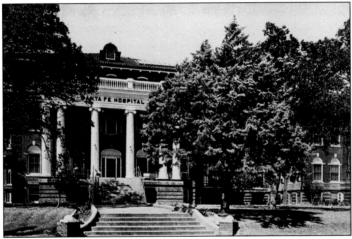

SANTA FE HOSPITAL, A PIONEER. Since the GC&SF Hospital Association was a new concept and the railroad employees were not accustomed to paying dues for prepaid healthcare, there was frequent discontent with the pioneering plan. Railroad workers also resisted leaving home when sick or injured in order to go to the hospital in Temple. It took time to convince them of the advantages of the comprehensive care provided under this one roof. Nevertheless, word spread throughout the GC&SF about the young doctors and great care at this new hospital. While Santa Fe Hospital was not the only medical facility in Central Texas, it was the most state-of-the-art for its time. The King's Daughters Circle, a charitable group serving the needy in 1894, petitioned the GC&SF Hospital Association for certain privileges at the Santa Fe. Again, a historic development waited around the next bend of the rails. (Curt Teich.)

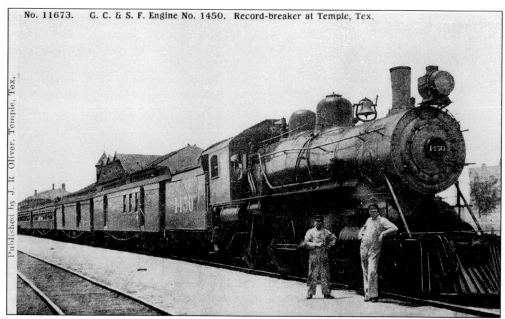

THE RECORD BREAKER. Gulf Coast & Santa Fe Railway Engine 1450 is shown at the depot in Temple following a record breaking run from Galveston. Two unidentified GC&SF trainmen pose with their speedy "Iron Horse." (Published by J.R. Oliver; courtesy Railroad and Heritage Museum.)

ANOTHER TRAINLOAD ARRIVES. In June of 1891, Santa Fe Hospital was established to treat employees of the GC&SF Railway. Today, that facility is known as Scott & White Santa Fe Center. Santa Fe Hospital is still on South Twenty-fifth Street, very near its original location. It began as a 20-bed wood-frame hospital operated by the GC&SF Hospital Association, formed by the Galveston businessmen who owned the GC&SF Railway. As a pre-paid health plan, the association functioned much like today's HMOs. (courtesy J.H. Roeder Collection.)

Ye Olde Apothecary. Willis Drugs was one of the pill rollers in early-day Temple. Besides potions, lotions, and medicines, Willis Drugs also dispensed cold drinks and other "High Grade Merchandise" that "Merited High Grade Advertising," or so they said. (Courtesy J.H. Roeder Collection.)

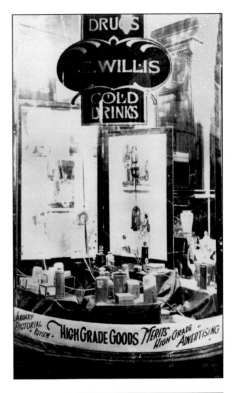

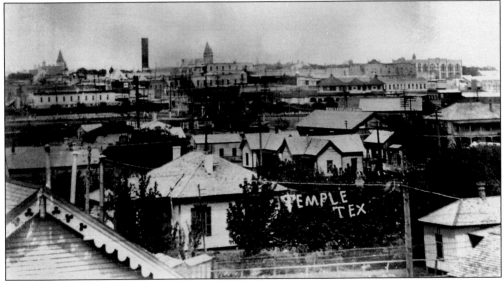

Civic Pride? Hometown pride permeates Temple's commitment to its natural beauty, its Texas-sized support of local sports, its emphasis on industrial development, and its care for the body through its world-class medical center and of the mind through a strong educational community. The greater Temple area boasts a population of over 111,000 but still maintains a "hometown" feeling. With a diversity of talents and interests, Temple combines a cosmopolitan outlook with a down-to-earth country "style" that creates an atmosphere supportive of personal, professional, and spiritual growth. (Courtesy J.H. Roeder Collection.)

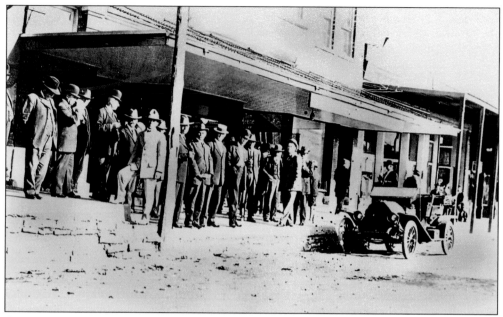

GENTLEMEN FROM TEMPLE. These well-dressed gents may be looking at the newfangled automobile parked on the dirt street, or perhaps they are only posing for the camera. One thing is for sure, however; they were participants in and witnesses to the birth and development of a remarkable Central Texas city. (Courtesy J.H. Roeder Collection.)

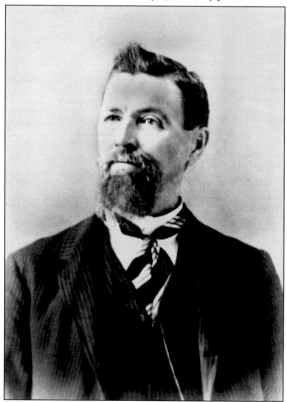

BABY STEPS. Property in Temple began being purchased June 29, 1881, and the bartering session was the occasion for a huge celebration. During the auction, some choice lots went for prices up to $300. Jonathan E. Moore's land dealings brought the railroad to town, and that led to the founding of Santa Fe Hospital. All of this seemed remarkable enough, and yet no one could see where these baby steps would take "Progressive Temple" in the years ahead. (Courtesy J.H. Roeder Collection.)

Five

KDH AND S&W
ARE THE PRESCRIPTION

When the King's Daughters Circle asked the GC&SF Hospital Association for "certain privileges" at the Santa Fe, a series of developments went into motion. The King's Daughters Circle was a benevolence organization founded by Mrs. Conn Sullivan, wife of a GC&SF conductor. The record is unclear about the "certain privileges" requested, and it may be coincidental, but in 1895 trustees of the Santa Fe Hospital Association voted to allow Dr. Scott and Dr. White to admit as many as two non-railroad patients to the hospital on a space-available basis. In 1899, however, the Sisters of Charity pointed out that their contract with the Santa Fe obligated them to treat only railroad patients. Hospital trustees rescinded their permission to treat private patients.

This seems to have motivated the King's Daughters Circle to open a small charity hospital in 1896. Dr. Scott and Dr. White donated time to treat patients there, as did other private practice physicians. Operating funds were raised through donations. As other patients who could pay for services began using the tiny hospital, demand outgrew its capacity. Dr. Scott and Dr. White differed on procedures with King's Daughters Hospital and in 1904 ended their affiliation with it. They instead founded a medical partnership called Temple Sanitarium. It is the ancestor of today's Scott and White Memorial Hospital and Clinic. Meanwhile, King's Daughters Hospital has continued growing and flourishing as an independent medical center.

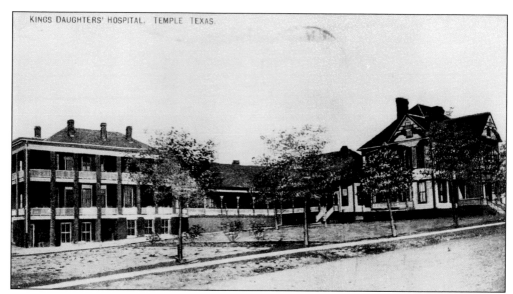

KING'S DAUGHTERS HOSPITAL, 1910. The first KDH, then a charity hospital, was in a small house on Ninth Street between Elm and French. It was adequate for only a short while, and around 1900 the hospital moved to a site at Twenty-second and Avenue C, the house of a Dr. Walker. A brick addition enhanced the larger frame house at this location. (E.C. Kropp Co., Milwaukee; courtesy Railroad and Heritage Museum.)

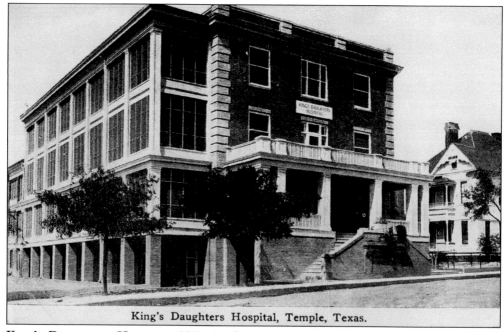

King's Daughters Hospital, Temple, Texas.

KING'S DAUGHTERS HOSPITAL, 1917. Brick structures replaced frame ones by 1928. Nearby, Graves Hospital at Twentieth and Avenue D served the black community in this era of segregation. Graves Hospital, owned by Mr. and Mrs. C.H. Graves, was open from 1916 until 1963. It was staffed by volunteer physicians from King's Daughters, Scott and White, and by black and white physicians in private practice. (Published by C.L. Reynolds, Druggist.)

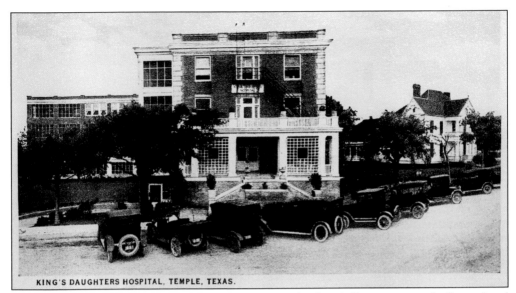

KING'S DAUGHTERS HOSPITAL, TEMPLE, TEXAS.

KING'S DAUGHTERS HOSPITAL, TEMPLE, TEXAS. The hospital's trustees gradually replaced inadequate wooden buildings with substantial red brick structures, incorporating what were then the latest advances in medical architecture. The facility was and is non-sectarian and is not associated with any outside organization. As finances permitted, new wings were added to the KDH facility over the span of years. (Curt Teich.)

KING'S DAUGHTERS CLINIC AND HOSPITAL. The facility was touted as "a modern fireproof building with 148 outside rooms." Stepping into the shade of that central courtyard doorway was frightful to any child who entered there—the doom and gloom of seeing the doctor. The only redeeming factor was the large pool filled with giant goldfish. Even that could be scary; who knew how deep the water was? (Curt Teich.)

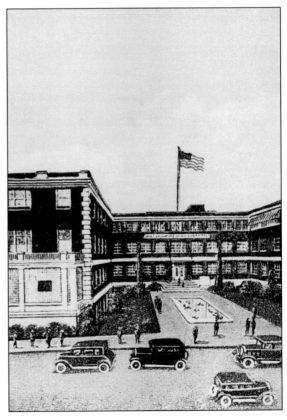

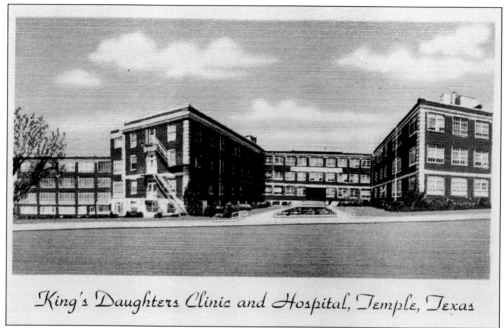

King's Daughters Clinic and Hospital, Temple, Texas

KDH, 1956. KDH moved to an existing frame house on the property pictured here in 1901. The first fireproof building was constructed in 1913, a south wing in 1917, and a north wing in 1928. The clinic was organized that year and occupied the new fourth floor. A private association operated the facility under the name King's Daughters, with no connection to any other institutions. (Curt Teich.)

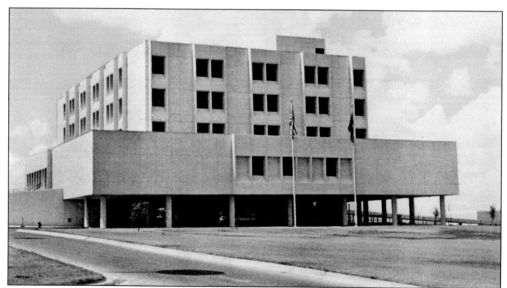

KING'S DAUGHTERS, 1975. Temple continued to enhance its reputation as a regional medical center with the opening of a new King's Daughters Hospital and Clinic in January 1975. Numerous additions have subsequently enhanced the campus while altering the look of the landscape on H.K. Dodgen Loop (Loop 363) between Thirty-first and Fifty-seventh Streets. The old KDH building now houses the Central Counties Mental Health, Mental Retardation Center.

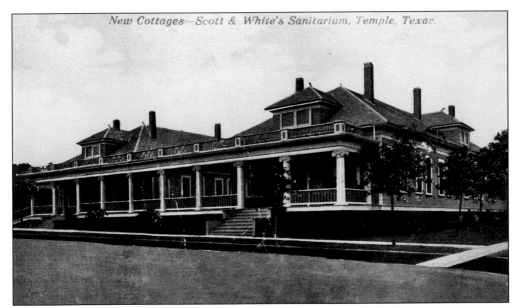

New Cottages—Scott & White's Sanitarium, Temple, Texas.

TEMPLE SANITARIUM. This building was at Fifth and Avenue F. Dr. A.C. Scott and Dr. Raleigh R. White Jr. formed an 1897 partnership for treating non-railroad patients in a private practice. As partners, each put his railroad salary and his private practice income into a single bank account. Each drew on that account for his needs. At year's end, they calculated who had the smaller withdrawal and he took a sum to equalize his share.

WOODSON'S EYE, EAR, NOSE, AND THROAT HOSPITAL. Dr. Scott's and Dr. White's private practice was in a house on North Seventh Street. They later formed Temple Sanitarium (seen to the right) on September 1, 1904, on Avenue F between South Fifth and Seventh Street. They asked Dr. J.M. Woodson, a local eye, ear, nose, and throat specialist, to open a hospital (on the left) for those specialties. (Curt Teich.)

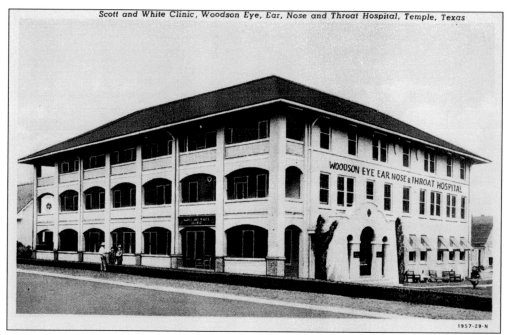

Scott and White Clinic, Woodson Eye, Ear, Nose and Throat Hospital, Temple, Texas

1957-29-N

THE AGE OF SPECIALISTS. Dr. Woodson's Eye, Ear, Nose, and Throat Hospital was a valuable adjunct to Scott and White's Temple Sanitarium, allowing them to focus on their surgical specialties. The sanitarium's charter emphasized that it was for the "study, prevention, relief, remedy, and care of any and all human disorders and diseases." Woodson's hospital was also later taken under Scott and White's umbrella. (Curt Teich.)

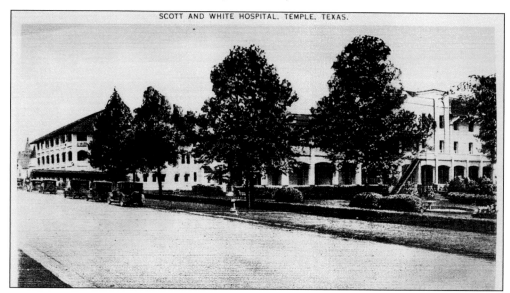

SCOTT AND WHITE HOSPITAL. TEMPLE. TEXAS.

SCOTT AND WHITE HOSPITAL. Looking west on Avenue G, Woodson's hospital and the new Scott and White construction form a medical monolith. Avenue G was bustling with cafes, drug stores, barber shops, a diner, a Ben Franklin store, service stations, rooming houses, a church, and other businesses. Westward a few blocks is Jackson Park dead-ending at Santa Fe Hospital's gate, with Twenty-fifth Street running left and right.

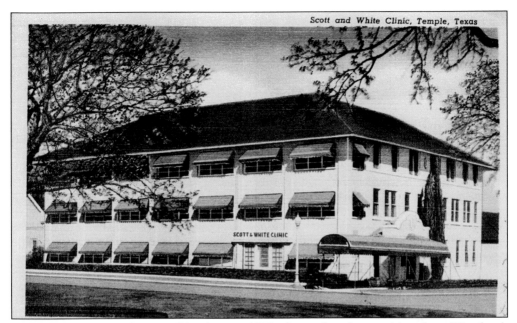

SCOTT AND WHITE CLINIC. This view, *c.* 1950, shows that the transition from Woodson's hospital to Scott and White's imprimatur was well advanced. The overall campus came to be quite extensive, six or more city blocks with dozens of buildings. Woodson's hospital came to be known as Scott and White's "Main Clinic Building." (Curt Teich.)

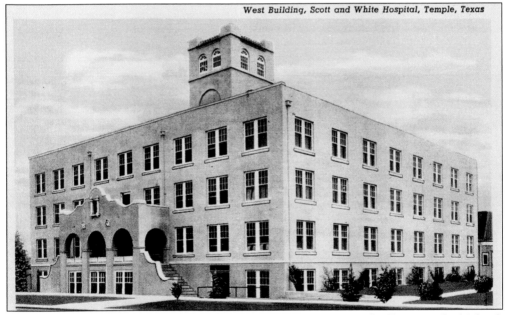

NEW WEST BUILDING. By 1908, Dr. Marcell W. Sherwood, graduate of Bellevue Medical School, also the brother-in-law of Dr. Scott, joined the staff. Dr. George Valter Brindley, graduate of the University of Texas Medical School, made another notable addition to the staff. Both doctors remained and became co-founders of the Scott and White Memorial Hospital and The Scott, Sherwood, Brindley Foundation. (Curt Teich.)

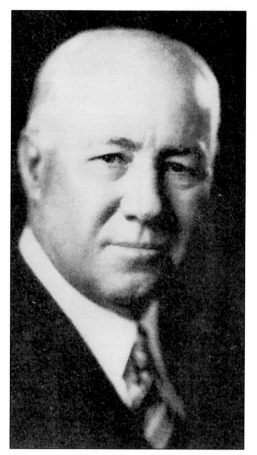

Dr. Aurthur C. Scott (1865–1940).
Born near Gainesville, Texas, on July 12, 1865, after country schooling, Scott went on to study with Dr. A.H. Conson. In 1882, he entered Bellevue Medical College in New York, receiving his M.D. degree in 1886. His internship in Pittsburgh brought him into contact with many of the leaders in modern medicine. He returned to Gainesville, married, and began private practice in 1888. He was appointed local Santa Fe Railroad surgeon and in 1892 became chief surgeon, necessitating a move to the railroad's hospital in Temple. In 1894, he appointed Dr. Raleigh White as house surgeon; in 1897 they formed a partnership and in 1898 established King's Daughters Hospital for the indigent. They also established Temple Sanitarium, chartered in 1905 as a general hospital and nurses' training school. A distinguished trauma surgeon, Scott developed the hot cautery knife for cancer surgery and pioneered concepts of industrial medicine, multi-specialty group practice, prepaid health insurance, and postgraduate medical education. His diagnosis and treatment of malignancies earned international recognition. A Presbyterian and a Mason, Scott died in 1940. (Courtesy Railroad and Heritage Museum.)

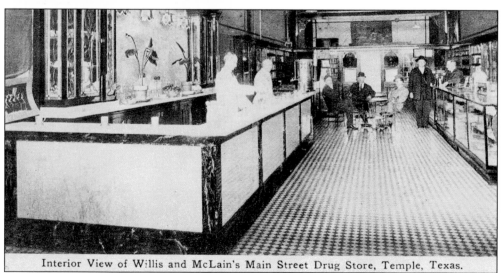

Interior View of Willis and McLain's Main Street Drug Store, Temple, Texas.

Drug Store. This is an interior view of the Willis-McLain Drug Store in downtown Temple, c. 1900. A bottle of Miles' Blood Purifier cost 90¢ and a bottle of Radway's Relief sold for 45¢. (Courtesy Railroad and Heritage Museum.)

DR. RALEIGH R. WHITE JR. (1872–1917). White, noted surgeon and son of a traveling Baptist revivalist, was born in Mississippi. The family moved to a Lockhart, Texas farm in 1881. Working the farm fell to young Raleigh, and when a drought destroyed his first cotton crop he determined to get an education. Graduating from Baylor University, White attended Tulane's College of Medicine, earning an M.D. degree. He moved to Cameron, Texas, and met Dr. Arthur Scott of Temple. In 1895, White scored top honors for the job of house surgeon at Temple's new Santa Fe Hospital. In 1897, Scott and White became joint chief surgeons for Santa Fe Railroad. In 1898, they, and the members of the King's Daughters Circle, established a hospital. They resigned in 1904 and formed Temple Sanitarium, caring for Santa Fe workers as well. In 1903, he married Annie May Campbell. White, a member of the First United Methodist Church, died of a heart attack in 1917, at age 45. In 1922, Temple Sanitarium was renamed Scott and White Memorial Hospital. (Courtesy Railroad and Heritage Museum.)

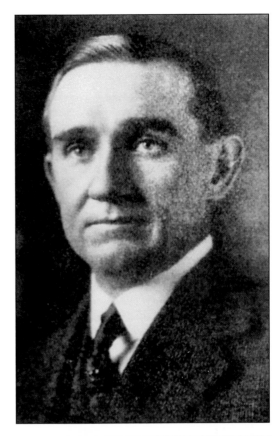

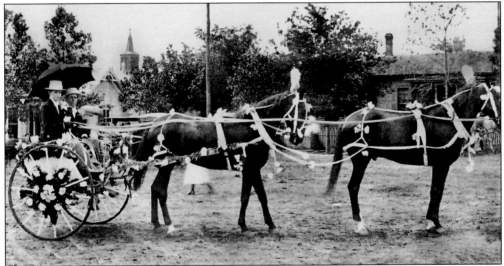

LET'S HAVE A PARADE. For many years, the citizens of Temple held an annual Flower Show Parade. They decorated themselves with flowers—along with anything else that would roll down the street—and entries were judged on beauty. Pictured here are Dr. A.C. Scott and Dr. Raleigh R. White with their entry in Temple's Flower Show Parade in the early 1900s. (Courtesy J.H. Roeder Collection.)

DR. CLAUDIA POTTER (1881–1970).
Claudia Potter, born in Denton County in 1881, always wanted to be a doctor and became a pioneer anesthesiologist. After high school she enrolled at the University of Texas Medical Branch at Galveston as the lone woman in her class and in 1904 only the sixth woman to graduate there. In 1906, she accepted Dr. Arthur Scott's invitation to become a staff member at Temple Sanitarium. For 41 years she served as head of the Department of Anesthesiology of Scott and White. Dr. Potter was the first full-time physician anesthetist in Texas. She is credited with being the first physician to administer gas anesthesia in a Texas hospital. During the 1900s many people saw hospitals as places to die. Therefore, surgery was frequently performed in homes, where Potter had to guard against open fires and stoves that might ignite the flammable anesthetics. She and the surgeons traveled to patients by horse and buggy, automobile, train, and even in a terrifying airplane. They performed surgery on kitchen tables and once in a cotton field on boards set across sawhorses. Potter died in 1970 having never married. (Courtesy Railroad and Heritage Museum.)

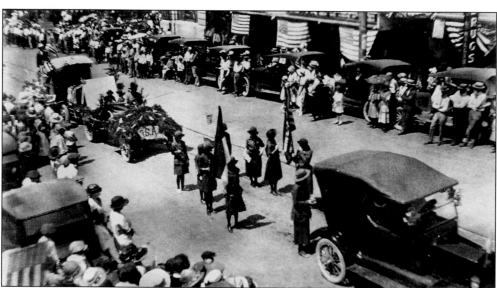

ANOTHER FIRST. The first Girl Scout troop in Temple is seen here marching in a downtown parade in 1922, led by Mrs. A. Ford Wolf, the group's organizer and leader. (Courtesy J.H. Roeder Collection.)

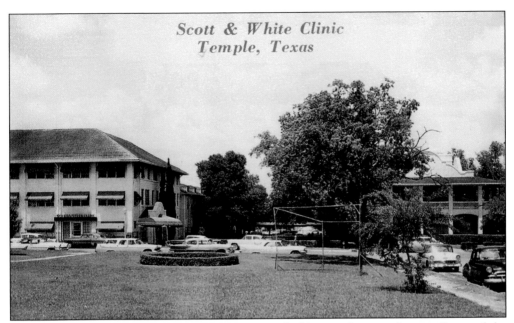

Scott & White Clinic
Temple, Texas

SCOTT AND WHITE CLINIC. This late-1950s view is looking north across Avenue G toward the main building of Scott and White Clinic (to the left), which had been Woodson's Eye, Ear, Nose, and Throat Hospital. The printed text on this postcard informs readers that this is "One of the Finest Medical Institutions in the Southwest." (Baxtone.)

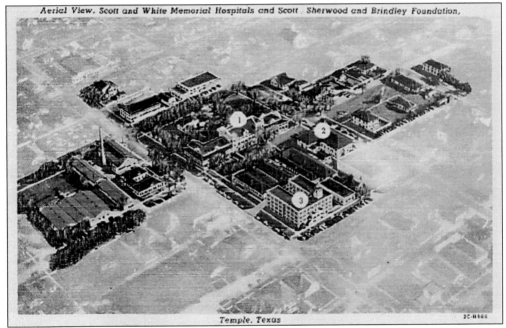

Aerial View, Scott and White Memorial Hospitals and Scott Sherwood and Brindley Foundation,

Temple, Texas

AERIAL VIEW. Pictured from above is the layout on the ground of Scott and White Hospital's facilities and those of the Scott, Sherwood and Brindley Foundation (looking toward the east). Building one is the Main Hospital facility; building two is the Main Clinic; and building three is the West Building. In all, there are 31 buildings scattered over five and a half blocks. (Curt Teich.)

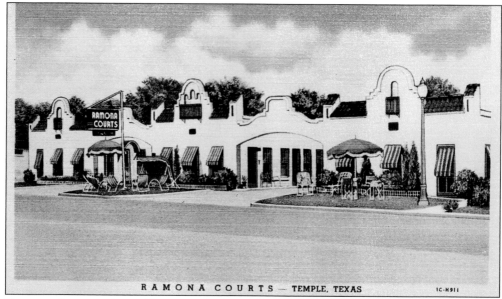

RAMONA COURTS — TEMPLE, TEXAS IC-H911

RAMONA COURTS. Pictured here is one of the many businesses just west of the hospital complex near Avenue G that served outpatients and visitors to Scott and White. The postcard says, "Near Scott & White Hospital. On U.S. Highway 81 & 190. Mr. & Mrs. James Palasota, Owners-Managers. Year-Round Air Conditioning." Ramona Courts still survives, despite the hospital's move to a new location. (Curt Teich.)

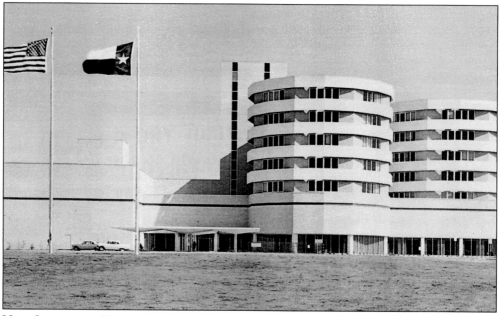

NEW SCOTT AND WHITE MEMORIAL HOSPITAL. After decades in the area between Fifth and Seventh Streets on Avenue G, Scott and White built a state-of-the-art hospital and clinic in 1963 on South Thirty-first Street. It included all of the latest in hospital design and added something new to the city's skyline. The facility was and is visible from miles away when approaching Temple from any direction. (Curt Teich.)

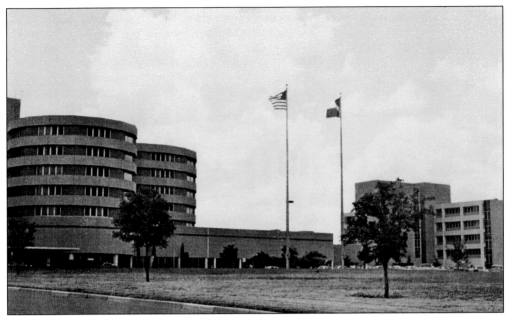

SCOTT AND WHITE HOSPITAL CONTINUES PIONEERING. Built on the highest elevation in Temple, a spot once known as Killarney Hill, Scott and White stands out from far and near. The hospital campus is undergoing a multimillion-dollar expansion, including a children's hospital and other 21st-century upgrades.

SCOTT AND WHITE'S PROFILE—FOR NOW. Founded in 1897, Scott and White Memorial Hospital and Clinic is a group practice, multi-specialty health care center for patients from Texas, the Southwest, and throughout the world. The Scott and White Health Plan is one of the highest rated prepaid health insurance organizations in the United States. The hospital even has its own zip code: 76508. (Photo by David Hansen, R.B.P., director of Medical Photography, ret.)

73

YET ANOTHER FIRST. Miriam Amanda (Ma) Ferguson, first woman governor of Texas, was born in Bell County in 1875. She attended Salado College and Baylor Female College at Belton. In 1899, she married James E. Ferguson, also of Bell County. Mrs. Ferguson served as the first lady of Texas during the gubernatorial terms of her husband (1915–1917), who was impeached during his second administration. When James failed to get his name on the ballot in 1924, Miriam entered the race. Before announcing her aspirations for office, she had devoted her energies to her husband and two daughters. Her family devotion and the combination of her first and middle initials led supporters to call her "Ma" Ferguson. She assured Texans that if she were elected; Texas would gain "two governors for the price of one." Between stays in the Governor's Mansion, the Fergusons lived in Temple. Her campaign sought vindication for the Ferguson name, condemned the Ku Klux Klan, and opposed new liquor legislation. Inaugurated 15 days after Wyoming's Nellie Ross, Miriam Ferguson became the second woman governor in U.S. history. After a brief hiatus, Miriam won her second term in 1932. She ran again in 1940 but was defeated. After her husband's death in 1944, Miriam retired in Austin. She died in 1961 and was buried alongside her husband in Austin's State Cemetery.

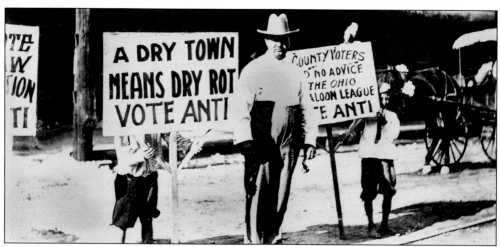

VOTE DRY. Prohibition was a big local issue in the 1920s, including one gubernatorial campaign of Miriam Ferguson. Since Texas allows beer and "hard liquor" sales based on local option voting, these "wet-dry" elections have been hotly contested through the years. (Courtesy J.H. Roeder Collection.)

Six

CAMP HOOD AND MCCLOSKEY GENERAL HOSPITAL

Two of the critical pieces in the picture puzzle that would become today's Temple, Texas, were shaped by the tragedy of World War II. It is always amazing to see the good things that can grow out of terrible circumstances. Soon after the fighting began for the United States in 1941, forward-thinking leaders in Temple created what they called the War Projects Committee. They understood that Central Texas had much to contribute to the war effort and that local projects would be beneficial to the city.

McCloskey General Hospital (now the Olin Teague VA Medical Center), Camp Hood, and other war-related facilities came to Central Texas because of the efforts of Temple's War Projects Committee. The group consisted of eight business leaders who pledged that they would not acquire property or make financial gain based on their advance knowledge about military installations coming to the area. The committee consisted of Chairman Frank Mayborn, W. Guy Draper, J.E. Woods, Dr. A.C. Scott Jr., Hill Gresham, J.E. Johnson, Frank Jones, and T.J. Cloud.

On the McCloskey hospital project, the committee received help from J.J. Rheinhold, special assistant to the president of the Santa Fe System in Washington, D.C.

Numerous other war projects came to the region—a prisoner of war camp in Temple, the Bluebonnet Ordnance Plant at McGregor, and others. However, none impacted Temple to the extent of Fort Hood and the veterans' hospital.

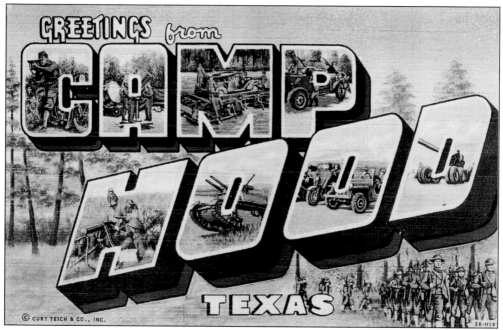

WELCOME TO CAMP HOOD. The troops had "franking privileges" during the war. They wrote "FREE" where the stamp went, included their military return address, and sent their mail without charge. Camp Hood, still a new base when this postcard came out, was designed as an armor training facility because of the vast stretches of land available. (Curt Teich.)

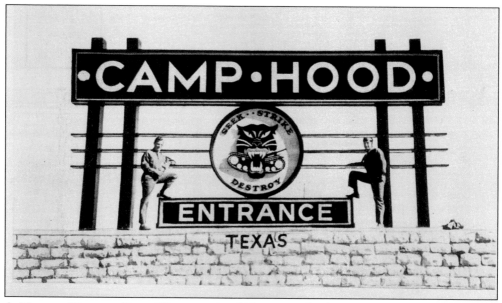

A MASSIVE MILITARY BASE. The expansive 340 square miles (217,551 acres) was equivalent to 25 percent of the sate of Rhode Island. It was named for Confederate General John Bell Hood. Known as Camp Hood throughout World War II, it was re-designated Fort Hood in 1950. Though located in Killeen—30 miles west of Temple—Fort Hood's impact upon Temple cannot be overstated.

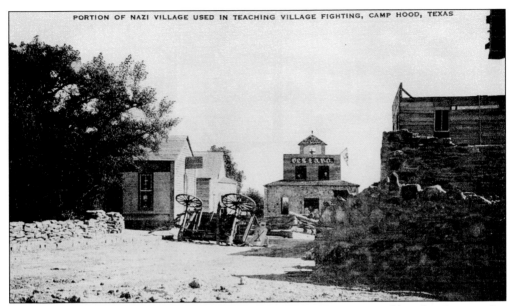

NAZI TOWN AT CAMP HOOD. In order to realistically train American soldiers in street combat like what they would encounter in Europe, the army recreated a typical Nazi village in Central Texas. The simulation paid great dividends. U.S. fighting men were fully capable of the house-to-house fighting required in these European settings. The technique is still in use; however, today's village simulates Iraq.

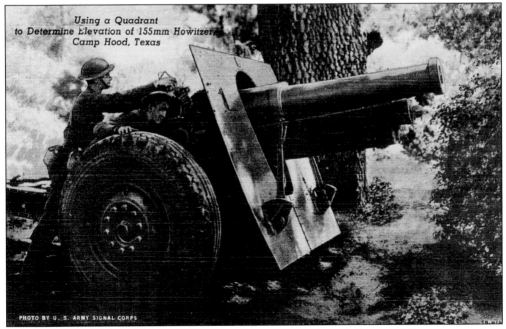

ARMY FIELD TRAINING. Photographed by the U.S. Army Signal Corps, soldiers are seen here using a quadrant to determine elevation of a 155-mm. Howitzer. This soldier rechecks his settings in preparation for firing this piece of field artillery. The vast size of Camp Hood allowed live fire exercises that were not possible on every military base. (Curt Teich.)

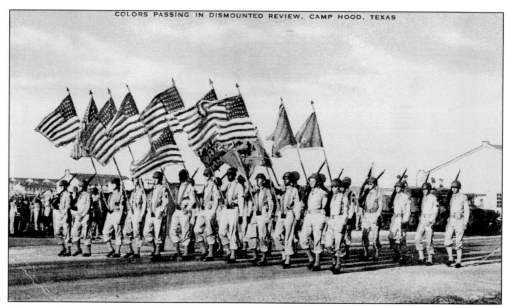

COLORS PASSING IN DISMOUNTED REVIEW. Since the dedication of the post in 1942, tens of thousands of soldiers have passed through Camp Hood. In 1967, it was designated a permanent two division post. Through the decades since 1942, thousands of military retirees and discharges have decided to remain in Central Texas as part of the fabric of local communities such as Temple. (E.C. Kropp Co., Milwaukee.)

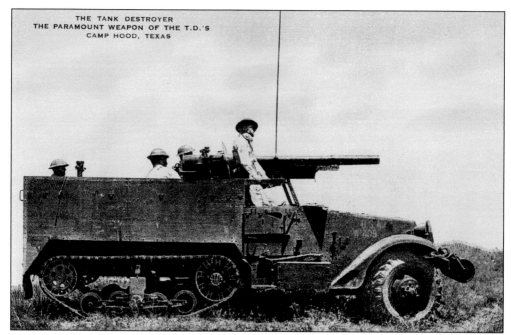

THE TANK DESTROYER
THE PARAMOUNT WEAPON OF THE T.D.'S
CAMP HOOD, TEXAS

THE TANK DESTROYER. Hitler's vaunted Panzer tank divisions were a formidable armored foe in World War II. Battlefield techniques learned in the valleys, on the hills, and on the flats at Camp Hood put the half-track tank destroyers seen here to work effectively, making them the paramount weapon of the army's tank destroyer units. (E.C. Kropp Co., Milwaukee.)

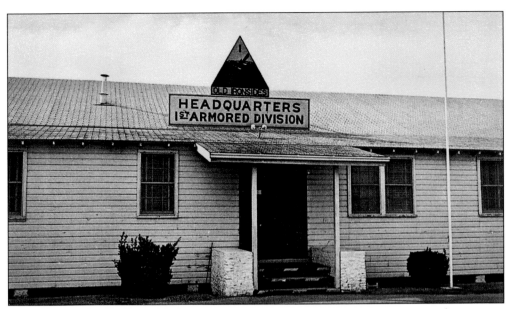

HEADQUARTERS BUILDING. The First Armored Division made its home at Fort Hood. For many years the post was served by hundreds of World War II vintage wood-frame buildings like the one seen here. Today, however, base operations have been housed in modern brick structures. Base facilities for military families comprise several on-post "villages" housing thousands of people.

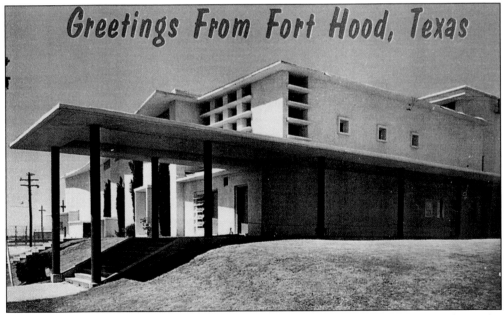

MAIN THEATER, FORT HOOD. Although military men and women are a common sight on the streets and in the businesses of Temple and Central Texas, Fort Hood can truly be a world unto itself. There are theaters, mess halls, bowling alleys, fitness clubs, barracks, post exchanges, and a lot more right on base. As a "combat ready" post, Fort Hood's personnel are always seen in fatigues while on duty.

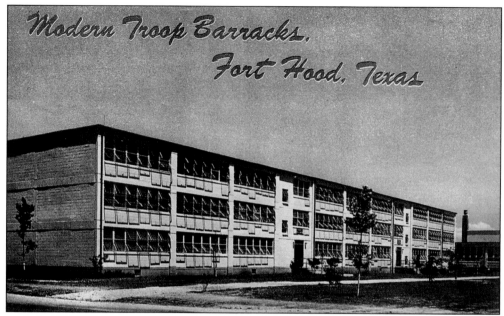

MODERN TROOP BARRACKS. Fort Hood, the world's foremost armored training center, instructs thousands of soldiers and technicians monthly. It is the largest military base in the world and is home to the most electronically digitized units in the army. Many of the personnel are housed in modern, fully equipped barracks featuring recreation rooms, laundries, and other amenities.

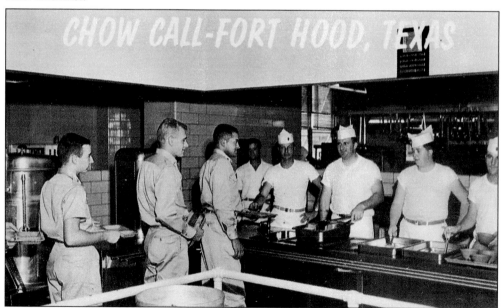

CHOW CALL—FORT HOOD, TEXAS (1960s). Through these serving lines pass the world's best-trained and best-fed soldiers. In *Bell County Revisited,* Martha Bowmer quoted a general who said that after three years of the post's existence, "If all the frankfurters consumed here [Fort Hood] were rolled into one big hot dog, it would stretch om Austin to Texarkana, and the evaporated milk cans, laid end to end, would reach 350 miles

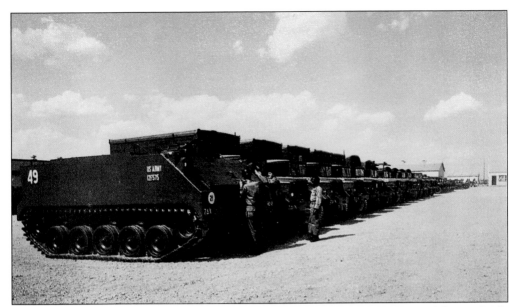

TYPICAL MOTOR POOL (1960–1970). Today's modern motor pools at Fort Hood feature APCs (armored personnel carriers), Abrams tanks, Humvees, Bradley fighting vehicles, heavy transport trucks, and other specialized vehicles. They have some heavy haulers, all capable of being loaded on railcars for transport to a seaport or wherever needed. Besides maintaining this variety of equipment, the motor pools are also responsible for training new mechanics. (PlastiChrome, by Colourpicture Publishers, Inc., Boston.)

FORT HOOD, TEXAS. Darnell Army Community Hospital is named in honor of Brig. Gen. Carl Rogers Darnell. In 1911, this modest officer gave to the world the method of purification of water by anhydrous chlorine, one of the greatest advances in sanitary services and public health in this generation. The process is still used to chlorinate drinking water, making it safe for use.

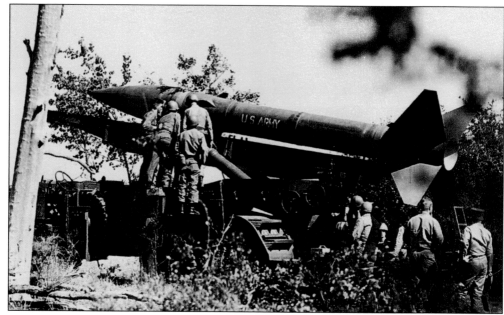

HONEST JOHN ROCKET. The army's Honest John Missile (1960s) is shown undergoing pre-flight checkout before blasting from its well-camouflaged mobile launcher. One of the Armored Division's most powerful tools, Honest John was a tactical field weapon capable of delivering both nuclear and standard explosive warheads. It had an accurate range in excess of 27,000 meters. (PlastiChrome by Colourpicture Publishers, Inc., Boston.)

MCCLOSKEY HOSPITAL. Dedicated in 1942, McCloskey General Hospital is now the Olin Teague Veterans' Administration Center. It was designed as a 1,500-bed general hospital occupying 54 buildings. Construction was completed in only seven months. This Army Signal Corps photo reveals the old Administration Building. Today, the Teague VA Center, along with Scott and White Hospital, is affiliated with the Texas A&M College of Medicine. (E.C. Kropp Co., Milwaukee.)

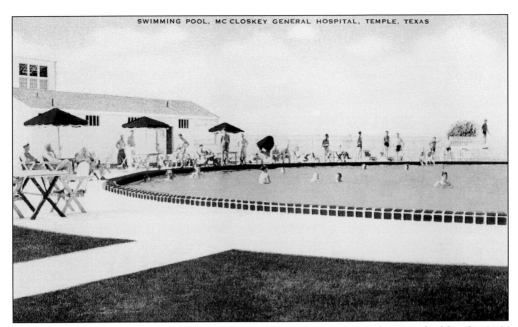

SWIMMING POOL, MC CLOSKEY GENERAL HOSPITAL, TEMPLE, TEXAS

SWIMMING POOL. Somewhere on its campus, as seen in this picture photographed by the U.S. Army Signal Corps, Temple's McCloskey General Hospital had a large swimming pool for its patients. Swimming is, after all, good exercise. The pool no longer exists, and nobody seems to know where it was located. (E.C. Kropp Co., Milwaukee.)

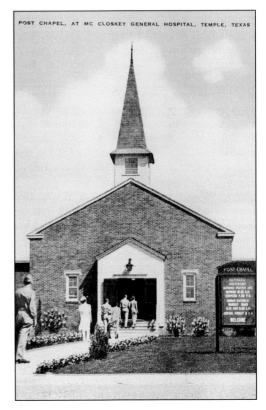

POST CHAPEL, AT MC CLOSKEY GENERAL HOSPITAL, TEMPLE, TEXAS

POST CHAPEL. All faiths were welcome in the chapel, photographed by the U.S. Army Signal Corps, at McCloskey Hospital, named for Maj. James McCloskey. He was killed at Bataan in 1942, the first regular army doctor to die in World War II. The hospital was one of the army's largest and was outstanding as a center for orthopedic cases, amputations, and neurosurgery. (E.C. Kropp Co., Milwaukee.)

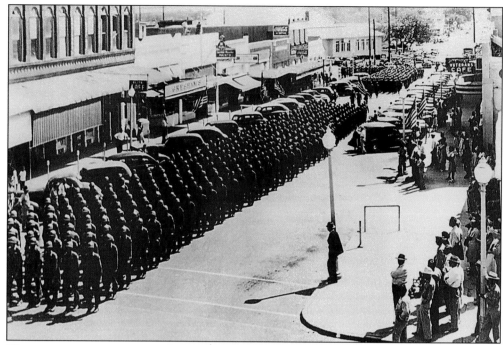

WARTIME PARADE. Troops in training at Camp Hood take time to march in a patriotic parade in downtown Temple during World War II. Notice the Veteran's Cafe on the right. (Courtesy J.H. Roeder Collection.)

THE WAR EFFORT. Fighting World War II required the services of tens of thousands of Americans, including many Army, Army Air Corps, Navy, and Marine veterans from Temple. They were at Pearl Harbor, at D-Day, and at the surrenders of the Nazis and the Japanese. Uncle Sam was a very real presence in the lives of many during the war. Many served on the home front, keeping railroads, hospitals, and vital industries running. Uncle Sam needed them all. (Courtesy J.H. Roeder Collection.)

Seven

GOOD TIMES

Temple's modern prosperity can largely be traced back to Frank W. Mayborn (1903–1987). He built a small newspaper group before newspaper syndicates were common, and he pioneered in radio and television. Mayborn supported education, promoted water development projects, raised funds for numerous causes, and was a patron of the arts.

He moved to Temple in 1929, when he and his father and two brothers purchased the Temple Daily Telegram, *shaping it into an award-winning newspaper.*

Besides the Telegram, *Mayborn published the* Killeen Daily Herald, *the* Sherman Democrat, *the* Taylor Daily Press, *and the* Fort Worth Sentinel. *He established the radio station KTEM in Temple in 1936, the first station outside a major metropolitan area. KCEN-TV went on the air in 1953, the first television station in Central Texas. Mayborn's interests included real estate development in Temple and the surrounding vicinity.*

Mayborn enlisted in the army as a private during World War II, rising to the rank of major and serving on Eisenhower's staff from D-Day to the victory in Europe. His ties with the military continued as he served numerous Fort Hood generals in advisory roles and toured Vietnam on a fact-finding trip for his old friend, Lyndon Johnson, during that conflict.

Mayborn took Temple along in his climb to success. His work in developing the area created lasting marks that will be a part of Central Texas from now on—medical facilities, industries, a giant military base, and airport facilities.

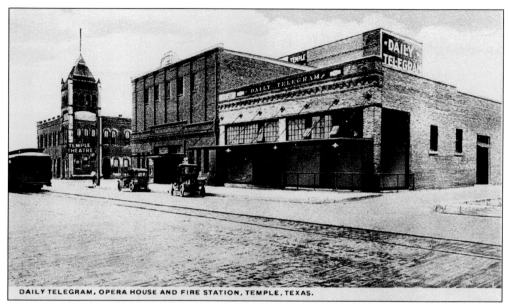

DAILY TELEGRAM, OPERA HOUSE AND FIRE STATION, TEMPLE, TEXAS.

***DAILY TELEGRAM*, OPERA HOUSE, AND FIRE STATION.** Frank Mayborn used the influence of his Temple *Daily Telegram* to attract the Texas A&M University Medical Center to Temple. In addition, Mayborn donated over 15 acres of land for the Frank W. Mayborn Convention Center, completed in 1982. He also worked with Congress for the construction of two Central Texas reservoirs, Belton Lake and Stillhouse Hollow Lake. (Curt Teich; courtesy Railroad and Heritage Museum.)

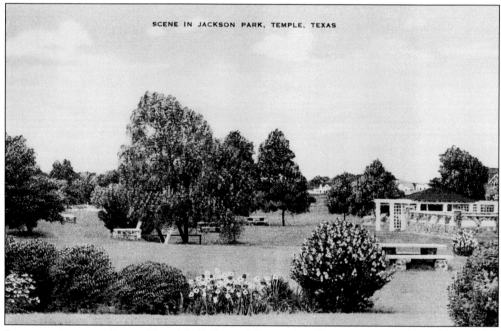

SCENE IN JACKSON PARK, TEMPLE, TEXAS

SCENE IN JACKSON PARK. Temple's Parks and Recreation Department provides citizens with swimming pools, disc golf, an 18-hole municipal golf course, baseball and softball diamonds, walking and biking trails, playgrounds, and other fun resources. Jackson Park is one of the city's oldest public parks. (Published by Barton News Agency, Temple; E.C. Kropp Co., Milwaukee.)

"DOES YOUR ROOF LEAK?" This small desk blotter (*c.* 1935) says if so, Temple Lumber Company's "Monthly Payment Plan will enable you to Re-Cover your Roof or Remodel your home. NO RED TAPE. You MUST Be Pleased." Temple continues enjoying growth in permits issued for new houses, totaling more than 300 during 2003.

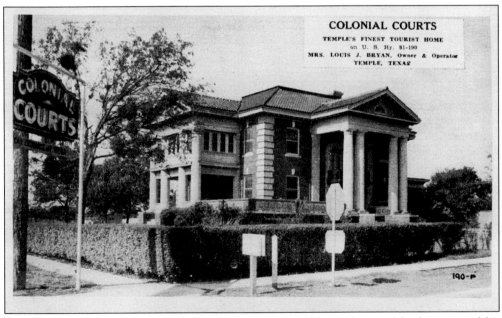

THE BARCLAY HOUSE. In 1912, William Barclay, successful merchant and landowner, and his wife, Martha, moved to Temple and built this magnificent home. It cost $65,000 to construct. The 12 outside columns cost $1,000 each. Years later it was called Colonial Courts, "Temple's Finest Tourist Home." Located at Twenty-fifth and Avenue H, the red brick Colonial revival house and its grounds have been restored to a private residence.

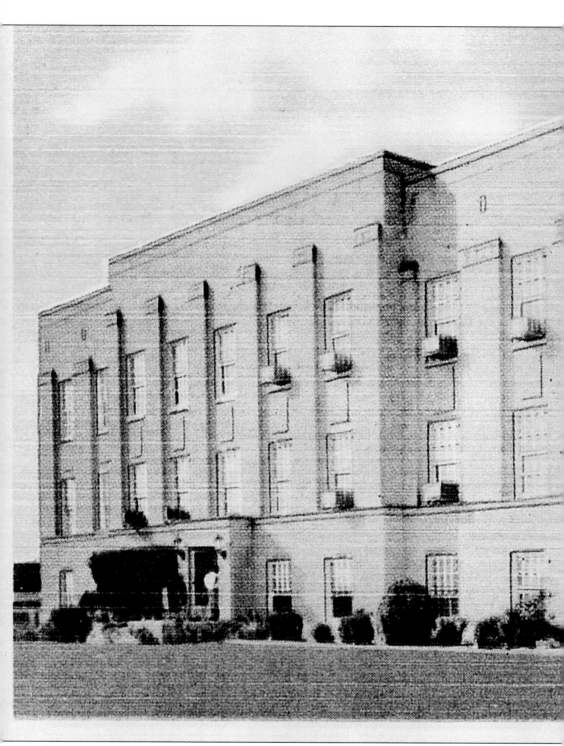

MUNICIPAL BUILDING. On his TexasEscapes.com website, John Troesser says he would bet that over the years there have been arguments about Temple's being the seat of Bell County. "People passing through . . . downtown . . . could easily swear they saw the courthouse," he

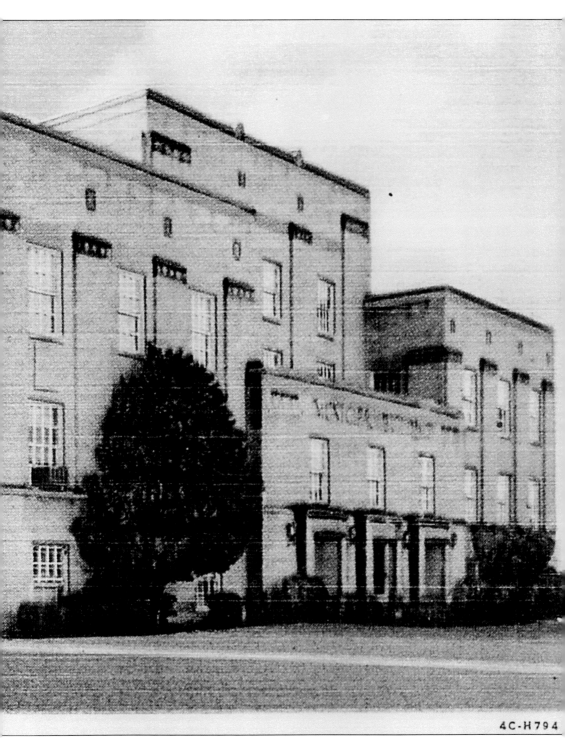

4C-H794

writes, " . . . because the Municipal Building sits exactly where one would expect a courthouse to be," (not to mention its close resemblance to a courthouse). (Curt Teich.)

TEMPLE AUTO COURTS. The postcard touts "Temple Auto Court, Inside City Limits on Highway 81, Air Cooled, Inner Spring Mattresses, Knotty Pine Walls & Oak Floors—Some Carpeted, Spacious Shady Lawn, Glad to Show Our Cabins, Privately Owned and Operated." A motel still operates at this location. (Tichnor Bros., Inc., Boston.)

THE REAL THING. Pictured here is the home of the Temple Coca-Cola Bottling Company at 1401 North Third Street. The building was erected in 1948. This plant actually bottled Coke for Bell, Lampasas, and San Saba Counties until a few years ago. Today it serves as a distribution facility. (Walt Hawkins Association of Temple and Dynacolor Graphics, Inc., Miami.)

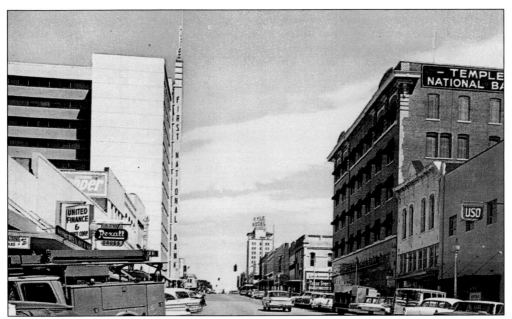

STREET SCENE. "The Prairie Queen" was a center of early Texas cultural, political, and business activity. This 1950s downtown street scene bustles with activity. Downtown has changed, of course, but remains alive with activity. Today, Temple is one of the most progressive and prosperous cities of medicine, agriculture, and industry. (Wayne Craig, Mothershed, Inc., San Antonio.)

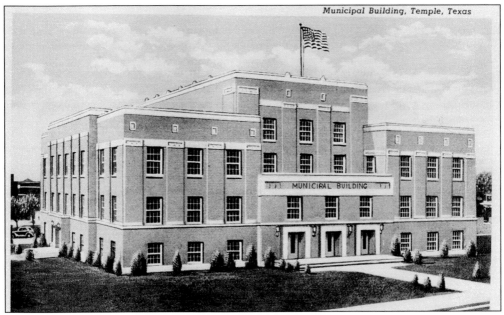

MUNICIPAL BUILDING. Constructed in 1928, the Municipal Building is at the heart of downtown Temple. This 1937 rendering shows early visions of solid civic construction. Besides city offices, the building included a large auditorium that provided a stage for years of annual Lions' Club shows, visiting magicians, traveling orchestras, and other entertainment. It underwent major renovations and beautification in the 1980s while John Sammons was mayor. (Curt Teich.)

FISHING ON THE BANKS OF THE LEON RIVER (DETAIL). Before Lake Belton was constructed in the 1950s, Temple received its drinking water from wells and from the Leon River. This scene, south of Temple, highlights the river's recreational value as well. Now, with Lake Belton as a water source, Temple has access to sufficient water for decades to come. (Curt Teich.)

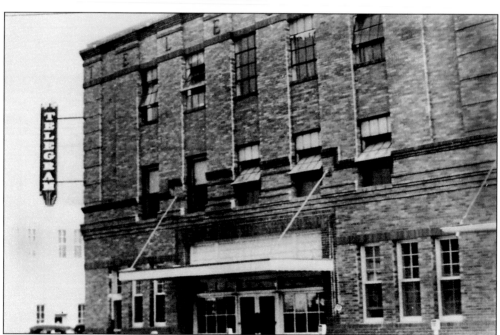

TEMPLE *DAILY TELEGRAM*. Located at Third and Avenue A, this is how the newspaper offices and plant looked when Frank Mayborn, his brother, and his father purchased the operation in 1929. When they outgrew this facility, Mayborn built a new home for his newspaper across on the west side of Third Street. (Courtesy J.H. Roeder Collection.)

Eight

TEMPLE
TODAY AND TOMORROW

This has been the story of Temple, Texas—or at least part of the story. First, this has been the story as told by the picture postcards available at a given time. Other cards would make it a slightly different tale. In the second place, the story is not yet over. New chapters are being written right now.

"Progressive Temple" has a long history of planning for the future, putting the plan to work, and then persevering in the task at hand. The city has been blessed with bold leaders and a business friendly environment. By any standard Temple is a vigorous, growing community. It is a place to build visions and raise families. Residential neighborhoods range from the stately historic district to the most sophisticated of contemporary residential settings. Temple is rightfully proud of its nationally recognized school system, churches for all faiths, and the full array of the retail segment of the economy.

Temple experienced significant growth in construction during 2003 (the last full year for which figures are available) mainly because of Scott and White's Center for Advanced Medicine. The project's permit totaled $104 million, representing the largest single value permit during 2003. Overall, Temple's building permits totaled a little more than $181,500,000 in 2003, according to the Temple Daily Telegram.

Known also as the "Wildflower Capital of Texas," Temple takes understandable pride in the community's appearance and in the recreational opportunities provided for the whole family.

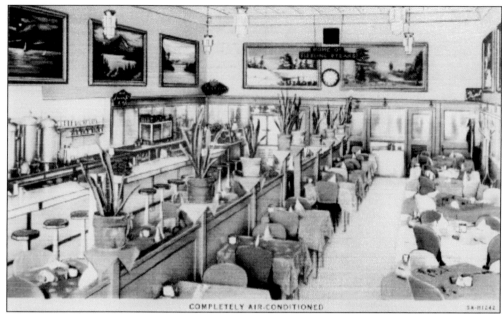

MOSS ROSE CAFE. The "in" place to eat in Temple was Moss Rose Cafe. It was "Completely Air Conditioned" and "Known For Food" (that's encouraging). Some preferred the High Hat while others enjoyed a nickel hamburger at the Shamrock or a 10¢ double burger at Cheesie Wynne's. Today, Temple features restaurants from Cheeve's Bros.' Steak House to the Bluebonnet Cafe and the usual franchise outlets. (Courtesy Brenda McGuire.)

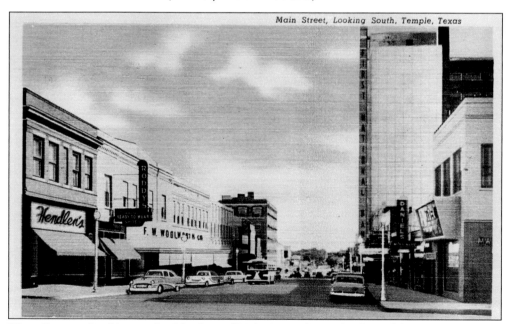

MAIN STREET. Looking south, this view of Main Street shows the face of downtown, *c.* 1960. Here are Hendler's, Woolworths, Marek Drug, Daniels, First National Bank, Temple National Bank, and other storefronts that were downtown fixtures. Much of the shopping has moved from town to suburban malls, but downtown still thrives with new uses for old spaces. (Curt Teich.)

94

NEW HOME OF THE FIRST NATIONAL BANK. This "new" office of the First National Bank kicked off the modern post–World War II era in downtown Temple. The advertising said, "Home of the First National Bank, the most Modern Bank and Office Building in Central Texas—ten stories high—86,500 square feet of floor space, providing perfection in light and office design. Every modern convenience, including all-season air conditioning, high speed elevators and Motor Banking in basement." Due to a few cars getting stuck in the tight circular drive-through motor bank, it was closed and a modern multi-lane drive-through bank was constructed across the street. Progress can be a bumpy road. (E.C. Kropp Co., Milwaukee.)

New Home and Office Building of the First National Bank, Temple, Texas

CALL ME EXTRACO. The First National Bank building is still a downtown landmark, though under "new management." Exporters and Traders Compress & Warehouse began its cotton compress and warehousing business in Waco in 1902. The company, now the largest privately owned financial institution in Central Texas, has been family owned and managed since 1902. Extraco Corporation (an acronym for Exporters and Traders Compress) participates in 247 volunteer community leadership roles and employs 535 Central Texans. The company conducts business in 13 Central Texas communities. (Courtesy Percy Francis.)

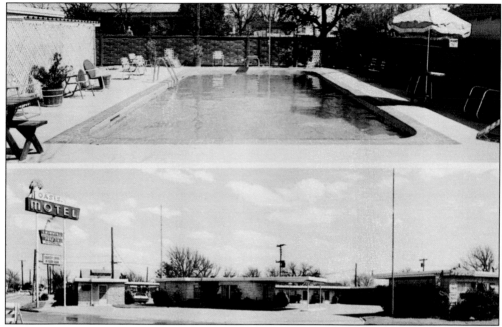

OASIS MOTEL. The Oasis is still around after quite a few years at 2701 General Bruce Drive (IH-35) in Temple. Their postcard noted the "Swimming Pool—30 air-conditioned rooms with telephones and CABLE TV, some with kitchenettes. Conveniently located to restaurants and downtown Temple. For reservations—Call Prospect 3-5296." (Windy Drum Commercial Photography, Waco, Texas and Dukane Press, Hollywood, Florida.)

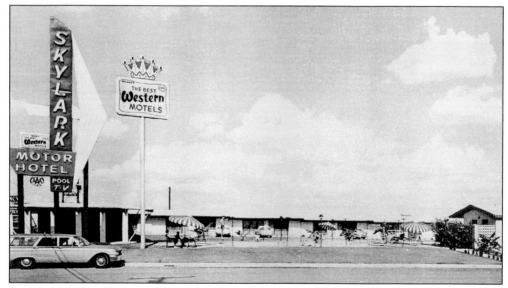

SKYLARK MOTOR HOTEL. This 1960s view of the air-conditioned Skylark in Temple shows a "modern, comfortable hotel on U.S. Hwy. 81 south of Temple. Piped Music and TV in every room, Torch Lighted Swimming Pool, Putters Golf Course, Conference Room, Children's Play area, Patio Garden and a connecting Restaurant. P.S. The rooms are just exquisite." (Lande Studio, San Antonio.)

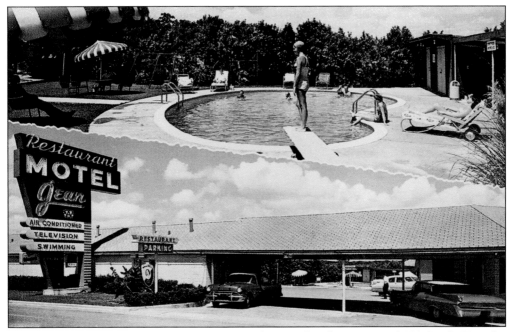

JEAN MOTEL AND RESTAURANT. The Jean Motel was at "Highways 81 and 190 South. Temple, Texas. An invitation to Texas hospitality. Lovely rooms with wall-to-wall carpeting, central heat, air-conditioning, telephone, television and radio." The Jean featured a swimming pool and children's recreation area. Their dining room had a grill, specializing in charcoal steaks and buffet luncheons. The Jean now functions as a low-income housing facility. (Strykers' Western Fotocolor, Fort Worth.)

HOSPITALITY INN. Located on Loop 363 and Thirty-first Street in Temple, the Hospitality had 80 rooms, direct dial phones, a pool, music in each room, cable tv, a club and restaurant, meeting rooms, and a large lobby area. The 1960s price of the noon buffet was only $1.25. Scott and White Hospital is across Thirty-first Street from Hospitality Inn. (Nationwide Advertising, Arlington.)

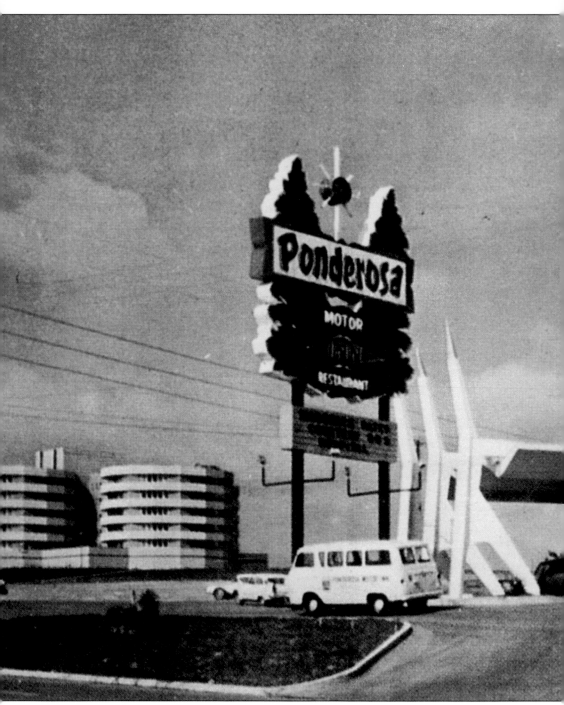

PONDEROSA MOTOR INN. The Ponderosa, in its day, was one of Central Texas's most fabulous motor inns. Located on South Thirty-first Street just south of Scott and White Hospital, the motel operated shuttle buses to and from Scott and White for guests who were going through the clinic. Their advertising said, "Adjacent to Scott and White Memorial Hospital, the Ponderosa offers unlimited convenience with truly luxurious living: 100 units, suites; Private Club; Gift,

Floral Shops; Restaurant, daily buffet; Barber, Beauty Shops; Pool. 'Luxurious Living At Modest Rates.' For Reservations call PR 8-5511." Eventually, Scott and White bought the motel, renaming it The Inn at Scott and White. It was torn down in 2004, making room for hospital expansion after Scott and White Properties opened its new Hilton Garden Inn hotel. (Walt Hawkins Photography.)

TEMPLE NATIONAL PLAZA. This was the new home of Temple National Bank. The building boasts over 70,000 square feet, including tenant office space, a glass atrium, a 10-window auto bank, and a two-story parking garage. In the 1980s, the City of Temple purchased the plaza to house the Temple Library on three floors, with tenants residing on the upper floors. The building layout was as follows: First floor Circulation Desk (Library Cards, Borrow and Return Materials, Pay Fines, Library Information), Audio-Visual Department, and Children's

Department; Second floor Large Print Collection, Reference Department, Adult Fiction and Non-Fiction, New Books, Genealogy Room, Local History Room, Reading Room, Adult Restrooms, Newspapers and Magazines, Internet Stations, Public Use Word Processor, and Young Adult Books; Third floor Board Rooms. As of January 2004, the library had 140,729 in total holdings, including 126,350 books and 14,374 audiovisuals. (Walt Hawkins Association of Temple.)

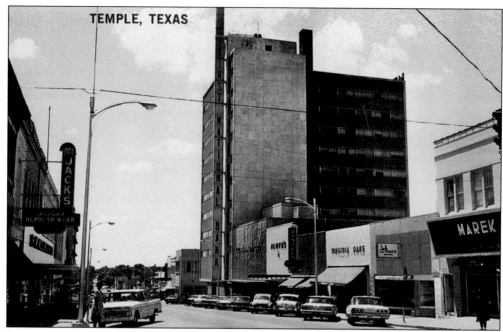

DOWNTOWN MAIN STREET. Temple is a principal Central Texas trade center and is noted for its vast medical facilities. A variety of businesses established themselves in Temple because of its centralized location and excellent transportation outlets. These included the American Desk Company (in 1921), a Coca-Cola bottling plant (1925), and Temple Junior College (now Temple College), which opened in 1926. The Great Depression interrupted the town's growth, but the 1940s brought waves of new residents. With Fort Hood located nearby, the Temple area is an attractive place for military personnel to retire. By the 1970s, Temple manufacturers included furniture, shoes, insulation, cottonseed products, electronic products, plastics, clothing, optical supplies, woodwork, and livestock and poultry feed. Temple acquired an agricultural experiment station and is home to the state offices of the U.S. Soil Conservation Service. The population of the greater Temple area (15-mile radius) was 89,848 in 1990. It is now (2004) estimated to be 108,787. The Killeen-Temple metropolitan statistical area estimates a population of 361,316 as of 2004. (Baxter Lane, Inc., Amarillo.)

TEMPLE CITY COUNCIL, 1981. Temple operates on a city manager–city commission form of government. The mayor is selected from among the city commissioners. Shown here is the 1981 city commission: Kenneth S. Baird, commissioner; Lewis Perry, commissioner; John F. Sammons, mayor; Robert M. Martin, mayor pro tem; and C.L. Walker Jr., commissioner. (Courtesy J.H. Roeder Collection.)

THE OLD ORIGINAL CAFE'. The location of the café seen in this postcard is on Highway 36, 81–190 business route. That is now on Adams Avenue, two blocks west of the Municipal Building, and the Old Original is now Talasek Insurance. Names like Frank Walker, Mike Addis, J.C. Pitts, and Doyle Phillips say "good food" to many people in Temple. Doyle Phillips' Steakhouse and Pitts' Bluebonnet Café still serve up great food. (Edney's Studio, Itasca.)

LAKE BELTON. Only eight miles west of downtown Temple, Lake Belton provides some of the finest water recreational opportunities in Central Texas. The lake offers marina and camping facilities, hiking, boating, fishing, hunting, parks, picnicking, and anything else done outdoors. The lake's surface area is 12,300 acres, the maximum depth is 124 feet, and normal fluctuation is three to five feet. (Printing Service of Texas, Waco.)

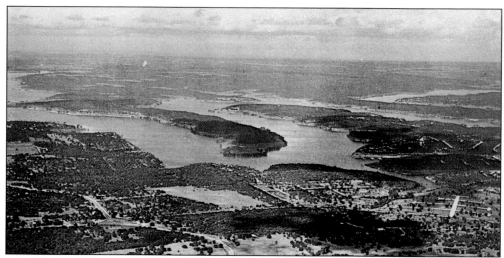

LAKE BELTON AND FORT HOOD. The lake provides a recreational outlet for personnel of Fort Hood and their families. The lake is also an excellent training facility. The U.S. Army Corps of Engineers built Belton Lake to control flooding within the Brazos River Basin. The lake supplies water for several communities, a fish and wildlife habitat, and abundant recreation opportunities for the public. The drainage area above the dam is 3,560 square miles. Belton Lake and Belton Dam are on the Leon River, part of the Brazos River Basin, and eight miles west of Temple in Bell County. The project is owned by the federal government and operated by the Army Corps of Engineers, Fort Worth District. Construction began in July 1949; the main dam structure was completed in April 1954, and impoundment of water began on March 8, 1954. (Products Supply Co., San Antonio.)

FIFTY YEARS OF BROADCASTING. In 1935, folks at the Temple *Daily Telegram* were interested in the new media of radio and television. They formed Bell Broadcasting Company and in 1936 secured a license for radio station KTEM, the first in Temple. The Mayborn interests no longer own KTEM, but after World War II this interest in broadcasting led to an interest in television. They filed for a license to permit telecasting in Temple. In the early 1950s, while most stations were going on the air with low power and modest antennas right in the middle of metropolitan markets, KCEN-TV went on the air in the country between secondary cities and rural areas with an 830-foot tower and studio facilities at Eddy, Texas. KCEN-TV is an NBC affiliate, serving Temple, Killeen, Waco, and Bryan-College Station. The station is located on a tract of land south of Eddy on IH-35. It now transmits from a tower that is 1,924 feet high. They also telecast in HDTV. (Courtesy J.H. Roeder Collection.)

LAKEVIEW DRIVE-IN. Frank Smith's enterprise is not in Temple, and yet it is part of Temple. Belton and Temple blend that way. One hot Sunday back in 1953, Frank and Nita Smith, like others, were out surveying the progress on Belton Dam. As Frank watched the sweating workers, he thought, "Man, a fellow could sell a lot of soda pop here today." Then, with the okay of the engineer in charge of the dam, the next weekend the Smiths rolled up in their old truck loaded with two tubs of iced-down soft drinks ready for business. Before the day was over they grossed $2.20. Each Sunday they returned, adding snow cones, then popcorn, and then hot dogs. They eventually built a small restaurant, a fishing camp, fishing supply shop, boat docks, and a year-round fishing pier. Then during the night of July 5, 1967, a fire destroyed most of their hard work. They were wiped out and had to start again from scratch. (Edney's Photography, Itasca.)

NEW LAKEVIEW INN. After a 1967 fire wiped out 11 years of hard work, a thriving business, and their home, Frank and Nita Smith were encouraged by friends and customers to rebuild—bigger and better. They did just that. The much-expanded operation includes dining areas such as the Laga Vista Room and the Anchor Club. They are available for parties, business meetings, or other functions. They also rebuilt the boat dock where patrons can just tie the boat and come up the hill to dine indoors or out. The new Lakeview Inn, built on the same site as the old one, overlooks Lake Belton and the dam from a high bluff. The scenery is spectacular, making this a favorite dining destination for many Central Texans. (Edney's Photography, Itasca.)

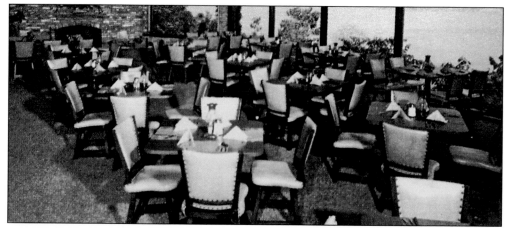

FRANK'S LAKEVIEW INN DINING ROOM. Frank's Lakeview Inn, overlooking beautiful Lake Belton, is a Central Texas institution. When Frank's opened, Lake Belton was the third largest Federal Control Lake in Texas. The expansive scenery invites patrons to relax and enjoy the split-level Blue Dining Room, which affords a view of the lake from each table. Others prefer dining in the deluxe atmosphere of the Gold Laga Vista Room, with its conversation pit. Other facilities include enclosed weatherproof fishing docks, a large marina with full service facilities, vacation cabins for rent, overnight trailer facilities, and campgrounds. The normal water clarity in Lake Belton provides four to six foot visibility. The lake's conservation pool elevation is 594 feet above mean sea level. It is a popular destination for boating, water skiing, fishing, and swimming. (Edney's Photography, Itasca.)

TEMPLE MERIDIAN. The Temple Meridian is one of several retirement and assisted living communities located in Temple. Besides pleasant weather, the medical care available from four hospitals draws people to the area. These communities offer restaurant style dining, private dining rooms, special events, housekeeping, activities programs, educational and cultural events, transportation, planned trips, maintenance programs (professional maintenance department, appliance maintenance, building and grounds maintenance), health and wellness programs, nursing home care (if needed), a full-time health services director, and an emergency alert cord in each apartment. Most of these facilities have kitchenettes in each apartment or cottage. They are attractively built and decorated, and residents may use their own furniture. Several provide swimming and exercise facilities, craft rooms, a library, game room, beauty and barber shops, security, and other niceties.

106

PEACEABLE KINGDOM. The Lampasas River in west Bell County is a place of beauty and peace. After the death of Jim and Daurice Bowmers' infant grandson from a heart problem, and after two other grandchildren developed diabetes, the Bowmers decided to share the beauty and peace with chronically ill children. The Peaceable Kingdom Retreat for Children was developed as a facility for the children, their families, and medical personnel on a 100-acre tract donated from the Bowmers' ranch. The first building, completed in 1990, is a stone, air-conditioned structure accommodating 20 children and medical personnel. Planning and additions continue. Scott and White brings out children with cancer, leukemia, heart problems, muscular dystrophy, multiple sclerosis, diabetes, and similar problems. Even the sickest have climbed into the tree house, paddled in the pool, and caught fish. The Bowmers' gift is rewarded each time an ill child catches a few minutes of happiness in that "peaceable kingdom."

LIFE SCIENCE RESEARCH. Community leaders foresee a "Temple Life Science Research and Technology Campus" built upon the city's existing medical research and educational infrastructures. Temple is home to six major entities in medicine, healthcare, and research. This unique partnership of the private and public sectors employs more than 12,000 physicians, researchers, technicians, and staff. This base includes the Texas A&M University System Health Science Center College of Medicine, with Scott and White Memorial Hospital as its teaching hospital, and the Cardiovascular Research Institute, a partnership of the College of Medicine, Scott and White, and the Olin E. Teague VA Medical Center. Add to that the Blackland Research and Extension Center, an additional sphere of research. Scott and White and related entities spent $200 million in capital investments for new construction and renovation between 2001 and 2004. Recently, the Temple Economic Development Corp. and the City purchased a 500,000-square-foot facility on 500 acres of land that was vacated by Texas Instruments. Scott and White leased nearly 89,000 square feet for office and warehousing operations. TEDC anticipates the creation of an incubator for biotech-related companies, which may provide the cornerstone for Temple's future job growth. (Courtesy J.H. Roeder Collection.)

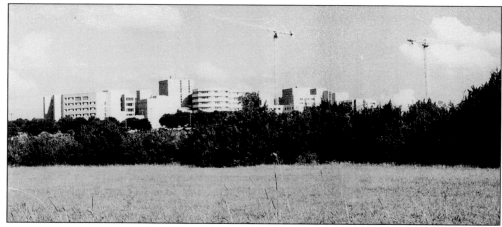

CHILDREN'S HOSPITAL. The 2004 Children's Miracle Network telethon brought news of a children's hospital within the future Center for Advanced Medicine at Scott and White (S&W). This children's hospital will provide care for children in a non-threatening environment. Scott and White has treated children since the hospital was established. In the early years, there were a handful of pediatricians to address children's needs. Over time, the child population as well as the demand for specialized care has grown. The new children's hospital will include 34 pediatric inpatient rooms, 40 neonatal intensive care unit beds, and eight pediatric intensive care unit beds. S&W participates as a clinical teaching campus for the A&M College of Medicine, so S&W has a teaching responsibility to educate medical students and residents to prepare them to eventually replace today's physicians. The medical center has a mission to create the type of children's hospital that will achieve three goals: clinical services for children, research, and education. (Courtesy Percy Francis.)

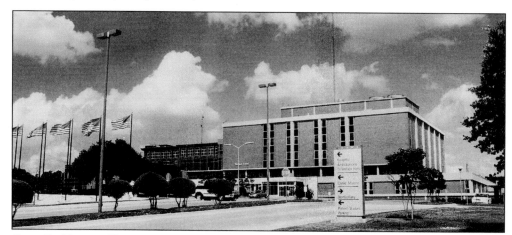

OLIN E. TEAGUE VETERANS CENTER. The Teague Veterans Center at Temple had its origins in the McCloskey General Hospital, activated June 16, 1942. McCloskey was one of the army's largest general hospitals providing care and treatment for military personnel. In 1946, the hospital was taken over by the Veterans Administration and became a general medical and surgical center. The two main hospital buildings were modernized and dedicated in 1967. The center was renamed in 1979 in honor of Olin E. Teague, who served 18 years as chairman of the committee on veterans' affairs in the U.S. House of Representatives. A 120-bed nursing home unit opened in 1981, and 1986 saw the completion of a $25-million clinical expansion project. A new domiciliary opened in 1990.

OLIN E. TEAGUE V.A. CENTER. By the early 1990s, the center consisted of a medical, surgical, and psychiatric teaching hospital, the domiciliary, the nursing home unit, and an outpatient clinic in Austin. In 1993, it had 510 authorized hospital beds, 120 nursing home beds, and 408 domiciliary beds with a staff numbering more than 1,400, including over 80 physicians. In the early 1990s the center was affiliated with Texas A&M University College of Medicine and provided clinical training for students in medicine, nursing, and allied health. (Courtesy Percy Francis.)

THE EXPERIMENT STATION. Pictured here is the Blackland Experiment Station in the late 1940s. The Texas Agricultural Experiment Station was established in 1887 to conduct research into the state's crop and livestock industries. Research was to point the way toward improved productive resources; lower production costs; improved quality of food, feed, and fiber products; expanded markets; and new and better methods for growing, processing, and distributing, as well as utilizing farm and ranch products. (Courtesy J.H. Roeder Collection.)

109

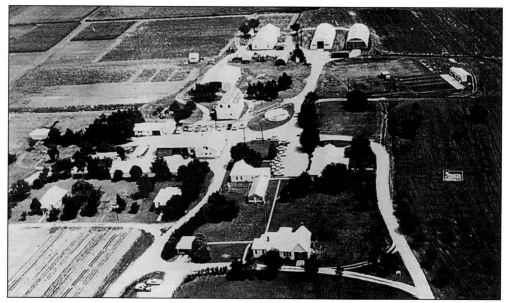

BLACKLAND EXPERIMENT STATION. The first permanent regional station opened in Beeville in 1894. By 1994, there were 23 regional Agricultural Research and Extension centers, including the one in Temple, which is a part of the Texas A&M University System. Seen here from the air is the Blackland Experiment Station as it appeared in the late 1940s. (Courtesy J.H. Roeder Collection.)

COLONIAL MALL. Built in 1973 for $12 million and first known as Temple Mall, this 575,127-square-foot shopping center has since been acquired by Colonial Properties Trust and renamed Colonial Mall–Temple. It is home to 65 retail stores including Foley's, J.C. Penny, and Dillards. Cotton Patch Cafe, a southern oriented dinner house, came to Colonial Mall–Temple in 2004. The restaurant occupies approximately 6,400 square feet. Premiere Cinema 12 operates a 12-screen movie theater in Colonial Mall as well. (Courtesy Percy Francis.)

CREATIVE PRESERVATION. Around 10 years ago, the Downtown Revitalization Committee began educating the public on the importance of revitalizing the downtown. In 1999, a team of urban planners envisioned the downtown area as a thriving economic and cultural base, despite high vacancy rates and crumbling facades. The brickwork on the upper portion of the buildings was worth saving, so with ingenuity and the desire to save what could be saved, the downtown revitalization people came up with a unique and practical solution: behind the renovated facades is a parking lot.

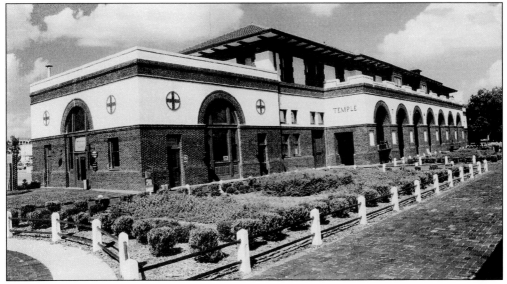

THE DEPOT'S FUTURE. Santa Fe departed the depot in 1989, leaving only an AMTRAK office. City officials negotiated with Santa Fe and in 1995 bought approximately nine acres surrounding the depot for $176,000. Santa Fe kindly donated the building. In 1996, a Texas state grant of $2.4 million plus $1.6 million from Temple financed the restoration. The grand reopening was held July 8, 2000, and is the cornerstone of downtown revitalization. Plans also call for adding Santa Fe Park, featuring a gazebo, walking trails, benches, arbors, and a fountain. (Courtesy Percy Francis.)

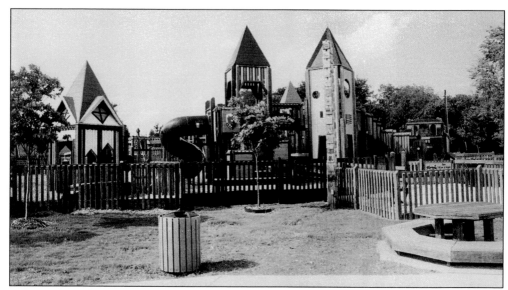

WHISTLESTOP PLAYGROUND. When plans for a children's playground collapsed under budget constraints in the Parks and Leisure Services Department in April of 2003, citizens decided this was a do-it-ourselves project. Instead of going on spring break, college kids grabbed hammers and went to work. Grandparents came with rakes and shovels. Parents came with work gloves, screwdrivers, and wheelbarrows. Even kids came to pitch in. The Parks Department sold "fence posts for the playground" at $25 each as a fundraiser. Businesses donated money, and building supply companies provided materials. Leadership Temple, part of the Chamber of Commerce, originated the WhistleStop Playground idea as a valuable addition to the community. The second phase of construction in 2004 added a covered pavilion and a bridge leading from the pavilion to the playground. The Burlington Northern and Santa Fe Foundation endowed $15,000 toward the pavilion. When it was over, everyone said, "We Built It Together!" (Courtesy Percy Francis.)

GOLF IN TEMPLE. The Sammons Park Golf Course, previously Temple Country Club, is now operated as a municipal golf course. It is an old-style par 70, 18-hole course that includes a 10,000-square-foot putting green, chipping green, and lighted driving range. The course has two lakes and water comes into play on 15 occasions. The Bermuda grass fairways are lined with numerous shot-altering pecan and willow trees. The greens are also Bermuda. Wildflower Country Club, built in 1987 by Leon and Charles Howard, features Tidwarf grass greens and Bermuda fairways. (Courtesy Parks and Recreation Department.)

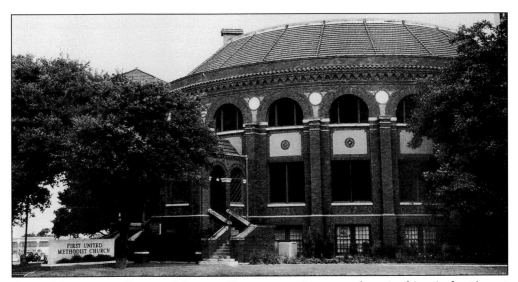

FIRST METHODIST CHURCH TODAY. The congregation moved to its historic location at Second and Adams in 1891, but a fire in 1911 destroyed their building. The congregation then retained the state's foremost architectural firm, Sanguinet & Staats of Fort Worth, to design the Romanesque revival–style building seen now. It is a Recorded Texas Historic Landmark. The round sanctuary features Art Deco motifs. Outside, Herringbone brick patterns and stone cross medallions embellish the red brick exterior. Like other aspects of Temple's past, First United Methodist Church is still serving the community today, with plans reaching into the future. (Courtesy Percy Francis.)

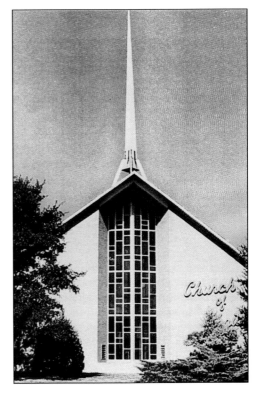

MOVING DAY. In 1932, a new congregation known as Central Church of Christ (now the Northside Church of Christ, located north of the Mayborn Center) began with a nucleus of 40 members from the old Seventh and G congregation. They met at Trainman Hall until a building was constructed at Fourth and Barton in 1935. Both the Central and the Avenue G churches had outgrown their facilities by 1957. They cooperatively formed Avenue T Church of Christ, about three blocks from the new Scott and White location. African-American Churches of Christ include the Crestview and the Tenth and Avenue M congregations. By 1960, the Avenue G group was again stressed for space. In 1962 they bought land on General Bruce Drive and erected a new building, adopting the name Western Hills Church of Christ (pictured here). They moved into the new building in June of 1963 and worship there still today. These churches corporately operate the Love of Christ food and clothing center for the city's needy.

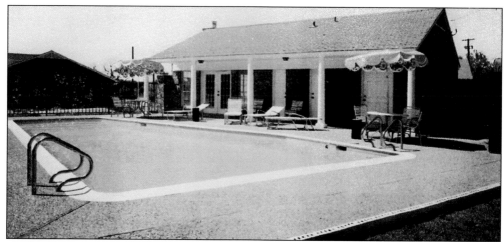

Diverse Temple. Begun as a model city built from railroad blueprints, Temple still has the vision to plan ahead. It is a thriving community that continues to attract families and progressive enterprises because of the city's economic vitality and foundation of values, ethics, and spirit. Today, more than 100 years after its birth, Temple is still the demographic center of Texas. Eighty-four percent of the state's population is within three hours of town. Temple has 20 apartment complexes (seen here is the pool at Plantation Estates), churches of all faiths, banks, credit unions, and the other necessities of the good life. (Courtesy Plantation Estates.)

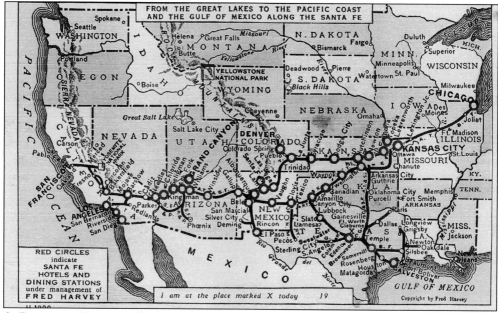

A Railroad Town. In the beginning, Temple's well being was tied directly to the GC&SF Railway and then to the Atcheson, Topeka & Santa Fe. As long as the railroad prospered, then Temple would likely do well. Then came a railway company hospital that attracted some gifted and far-sighted physicians, and a series of events was set in motion, shaping the town's future. Hometown pride still drives Temple's commitment to its natural beauty; and the city's hard working people and innovative leaders foster economic growth and prosperity. (Courtesy Railroad and Heritage Museum.)

SCOTT AND WHITE NURSES. To put things in perspective, in 1873, Florence Nightingale started the nation's first school of nursing at Bellevue Hospital in New York City. Arthur C. Scott enrolled in medical school in 1883. The John Sealy Hospital School of Nursing opened in Galveston in 1890 (major benefactors of the school were officers of the GC&SF Railway). In 1891, the GC&SF Railway built a hospital for their employees in Temple, hiring Sisters of Charity to function as nurses and administrators. Santa Fe Hospital hired Dr. Scott in 1892, and in 1895 Dr. Raleigh White was taken into service. Dr. Scott and Dr. White, in 1897, charter their own hospital. When Temple Sanitarium opened in May of 1904, patients resided in a boarding house. By September of 1904, the hospital began housing its own patients and hired nurses. By the end of September 1904, Temple Sanitarium Training School is a reality. Allie Brookman and Maggie Castleman were the first graduates from the school. (Courtesy *Scott & White Quarterly*.)

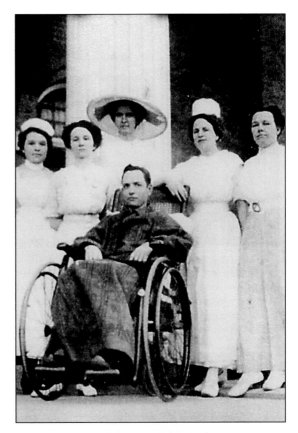

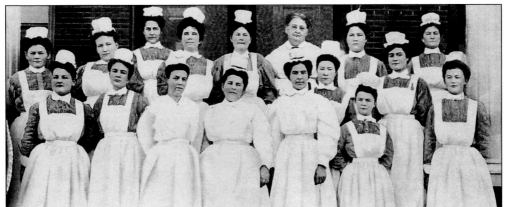

NURSING'S FUTURE. Scott and White's mission statement makes a commitment to high quality, comprehensive healthcare, enhanced by medical education and research. These are the ingredients that have earned S&W an overall reputation for excellence, especially in the field of nursing. Today's nurses, unlike those in the early days of the profession, have real opportunities for continuing their healthcare and science education. The Scott and White School of Nursing is actively involved in research to improve the quality of healthcare. A current study seeks to identify what persons are at the greatest risk of falling and determining ways to reduce the likelihood of injury. The study is a joint project of S&W and the Texas A&M School of Rural Public Health. (Courtesy *Scott & White Quarterly*.)

Enjoyment of the Arts. The premiere arts center in Central Texas is Temple's Cultural Activities Center (CAC). Visitors experience live stage performances by professional artists for children and adults, visual art galleries and classes, dance classes and camps, summer arts camps, reception and meeting rooms, and more. The Artist-for-Hire program sends artists into classrooms, bringing live lessons in music, dance, living history, public speaking, poetry, and literature. The CAC provides hands-on enjoyment of the arts for all area residents, especially children. They bring together diverse groups of people through shared interests in the arts. The CAC attracts

92,000 visitors annually, and more than 20 local organizations use CAC facilities. The Hands-On program incorporates theatre, art, a gallery visit, language, and movement into a cross-cultural field trip, which draws more than 2,000 third- and fourth-grade students annually. More than 11,000 kindergarten through eighth-grade students yearly receive an Arts-in-Education program provided by the CAC. The Frank W. Mayborn Stage and Auditorium hosts over 70 entertainment events yearly, including the CAC's Performing Arts Season, Family Fun Series, and Central Texas Orchestral Society's Concert Series. (Courtesy Percy Francis.)

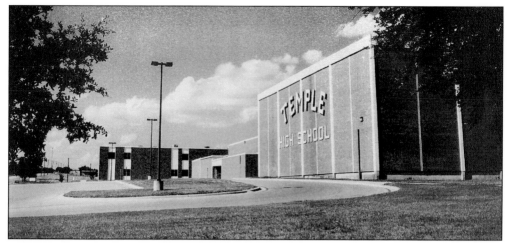

TEMPLE SCHOOLS. Temple High offers a variety of accelerated courses including college-credit in high school, advanced placement, Pre-IB, credit by exam, and Texas Scholars. Career certification opportunities include fire science technology, phlebotomy, emergency medical technician, certified nurse assistant, CISCO computer technology, and cosmetology. The class of 2001 made their town proud by earning over $3 million in scholarships. THS offers athletic and physical education programs for girls and boys, including 20 University Interscholastic League (UIL) organized sports. (Courtesy Percy Francis.)

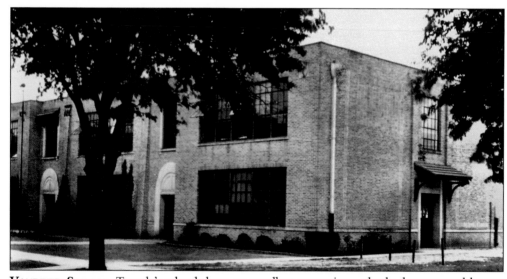

VANDIVER SCHOOL. Temple's schools have an excellent reputation—clearly demonstrated by test scores that exceed state and national averages. The area boasts numerous private schools for students from pre-kindergarten through 12th grade. Medical, industrial, agricultural, and environmental research facilities permeate the business, educational, and medical communities. Temple Independent School District (TISD) has nine elementary schools, three middle schools, and one high school with student enrollments totaling 8,359. Gifted and talented activities are available at all campuses, and outstanding programs include character education, careers and technology education, robotics, Air Force Junior ROTC, multi-cultural and diversity studies, special education, and reading recovery. TISD has a tradition of excellence in the performing arts, visual arts, and communications. Vandiver School houses the GED and adult education programs. (Courtesy J.H. Roeder Collection.)

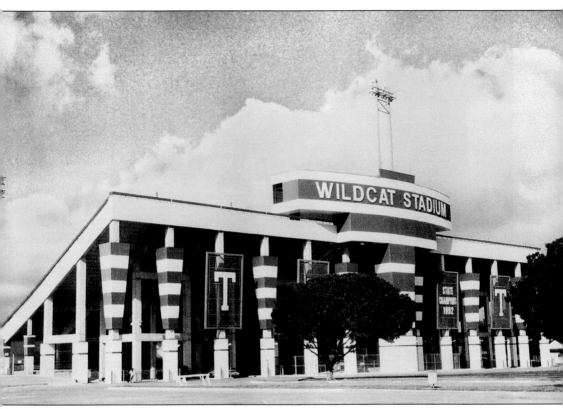

WILDCAT FOOTBALL. There are many proud football traditions in Central Texas, and Temple has one of the best. Temple Wildcat football teams have won two state football championships. Wildcat Stadium, a natural turf field, seats more than 5,000 fans, and is located on the high school campus on North Thirty-first Street. The past glories of Wildcat all-time team records include 600 wins, 227 losses, and 35 ties. That is an average of .716, the highest record in Texas. They appeared in state championship games in 1940, 1941, 1951, 1952, 1976, 1979, and 1992, winning it in 1979 and 1992. The Wildcats have enjoyed 13 undefeated regular seasons. The Temple Wildcat football team has many traditions that mean much to players and fans. The Blue Dot, Periballo, "48 minutes to play—a lifetime to remember," and blue front–white back pants are a few of the traditions. Hard work and dedication are big traditions at Temple High School. Working hard in the off-season and during the season enables the Wildcats to win. (Courtesy Percy Francis.)

TEMPLE COLLEGE. A community college offering a range of academic and technical programs, Temple College (TC) awards associate degrees or certificates of completion in several fields. Community programs and workforce training enhance local educational opportunities. Chartered in 1926, TC is a fully accredited, full-service community college with a faculty and staff of 350 members. (Courtesy Percy Francis.)

ADMINISTRATION BUILDING, 1981. More than 3,575 students are enrolled in college credit classes and an additional 1,450 in community education and workforce training classes. In the academic division, the college offers the first two years of work in most major fields leading to the bachelor's degree. (Courtesy J.H. Roeder Collection.)

MARY ALICE MARSHALL FINE ARTS BUILDING, 1981. Temple College is recognized for outstanding programs in vocational nursing, dental hygiene, emergency medical services, medical laboratory technology, surgical technology, and respiratory care. Technical programs prepare students for employment in areas requiring specialized training. Some technical courses lead to an Associate of Applied Science degree, while other programs lead to certificates of completion. (Courtesy J.H. Roeder Collection.)

HUBERT M. DAWSON LIBRARY, 1981. The Community Education Division of TC offers non-credit classes for upgrading skills, career preparation, and online courses. The Community Education Division provides customized workforce training for business and industry that can be completed at the college or on the job site. (Courtesy J.H. Roeder Collection.)

FRANK W. MAYBORN CIVIC AND CONVENTION CENTER. The civic center is named in honor of Frank Willis Mayborn, born in 1903, a leading figure in the development of Bell County. After arriving in Temple, he acquired the Temple *Daily Telegram*, serving as editor and publisher until his death. He also owned KCEN-TV. An advocate of a convention center for Temple, Mayborn donated over 15 acres of land to the city for the Mayborn Convention Center, completed in 1982. Frank Mayborn died of a heart attack in Temple in 1987. The Mayborn Center contains 40,000 square feet of exposition, performance, and meeting space. Its 18,540-square-foot main hall is divisible into as many as three large multi-purpose rooms. Six carpeted, self-contained meeting rooms surround the main hall. The Mayborn Center accommodates meetings of 2,400, performances of 2,001, exhibits of 120 10-by-10-foot booths, banquets of 1,650 and more, and dinner dances of 1,200 and more. The Mayborn Center staff considers these items its specialties: customer service, food/beverage services, assistance in hotel/motel room blocks, beginning to end event planning, and the highest quality in AV equipment. (Courtesy Percy Francis.)

W.R. Poage Federal Building, 1981. A modern downtown landmark, the Poage Federal Building houses offices of the Soil Conservation Service, the U.S. Department of Agriculture, and related agencies. (Courtesy J.H. Roeder Collection.)

SPJST. The full name of this fraternal benefit society is the Slovanska Podporujici Jednota Statu Texas (Slavonic Benevolent Order of the State of Texas [SPJST]). To non-members, SPJST is easily misunderstood. For some, it is an insurance company; to others, it's a social club; and to still others, a cultural preservation society. Between 1834 and 1900, approximately 200,000 people of Czech descent immigrated to America. Many ended up in Texas. In the 1880s, Czech pioneers in Texas joined other people of Czech descent in the United States in a fraternal benefit union called the C.S.P.S.—the Cesko-Slovanska Podporujici Spolecnost—now known as the Czechoslovak Society of America (CSA). Eventually, 7 of the 25 Texas CSA lodges withdrew from the older society, becoming the vanguard of the fledgling SPJST. Records indicate that the SPJST started operations on July 1, 1897, with 782 members and 25 lodges. The headquarters moved to Temple in 1953, in the remodeled third floor of the Professional Building at Second and Central. In time, it became evident that larger quarters were needed. Groundbreaking was held in 1969 with formal dedication ceremonies on January 31, 1971. The SPJST Library, Archives, and Museum are open to the public on North First Street, across from the post office. (Courtesy J.H. Roeder Collection.)

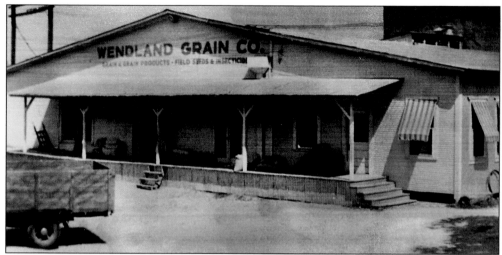

FROM GRAIN ELEVATORS TO LIBRARY BOOKS. Wendland Farm Products, Incorporated, of Temple (seen here in a vintage photo) is one of only a few locally owned flour mills in Texas. A Temple native, Errol Wendland took it upon himself to find a solution to Temple's problem of needing a 21st-century library. Because libraries are one of the vital repositories of any community's knowledge, it must have a library equal to its aspirations if they are to grow and prosper. Many communities know this, but few have the vision and the ability to make it happen. The City of Temple and its citizens are fortunate to have such a man living among them. He would not take "no" for an answer. Wendland made it his personal goal to acquire something better for his community. Wendland spearheaded the effort to buy the Bank One Plaza, resulting in the first-class library facility the city enjoys today. Certainly he did not accomplish this alone, but his vision and inspiration served as the launching point for all that was to follow. (Courtesy J.H. Roeder Collection.)

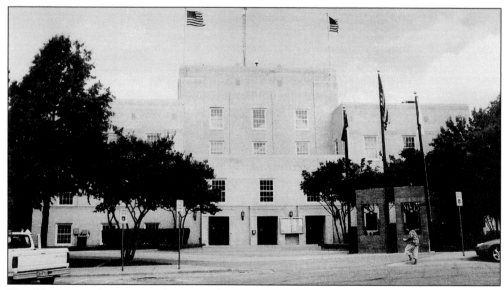

THE MUNICIPAL BUILDING. Like many things in Temple, the old is new again. The Municipal Building is three-quarters of a century old, but because of renovations and technological updates it remains a vital asset to Temple even today. (Courtesy Percy Francis.)

DR. AND MRS. J.M. WOODSON. When there was a vacancy in the position of house doctor at Santa Fe Hospital in the mid-1890s, Dr. A.C. Scott prevailed on a fellow physician from Gainesville, Texas, to come fill that post for a short time. That friend, Dr. J.M. Woodson, and his wife, Anna (seen here), liked Temple and eventually moved to the growing new town. Dr. Woodson later began his own practice treating eye, ear, nose, and throat problems. They could not have known where medicine would lead their newly adopted hometown. (Courtesy J.H. Roeder Collection.)

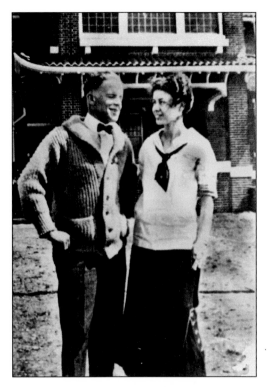

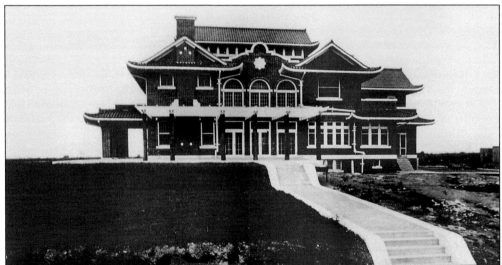

HOUSING BOOM BEGINS. When Dr. James M. and Anna Woodson built this fabulous prairie-style house with a pagoda-style roof north of downtown Temple, the land around it was only slightly wilder than the city's environs. Both required a lot of civilizing; however, it was happening, and strong souls like these helped mature the Prairie Queen faster than most frontier towns. When constructed in 1914–1916, the house cost $85,000. Noted architect Olaf Cervin, a contemporary of Frank Lloyd Wright, designed the house. Temple's housing boom continues today. The Woodson home, which many locals refer to as "the Chinese Mansion," is still inhabited and may be seen at 1302 North Eleventh. (Courtesy J.H. Roeder Collection.)

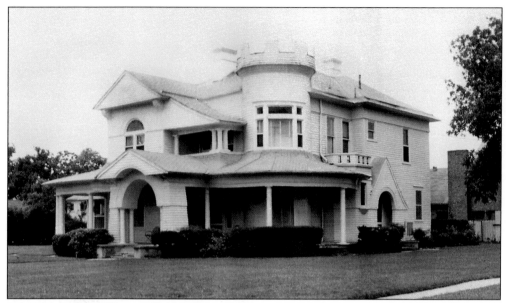

HISTORIC HOMES. The north side of Temple is crisscrossed by quiet tree-lined streets and many magnificent old homes in styles ranging from Greek revival to Colonial to Spanish—and a lot of other visual treats. North Ninth Street is a museum of beautiful old homes that act as counterpoint to the modern city Temple has become since 1881. (Courtesy J.H. Roeder Collection.)

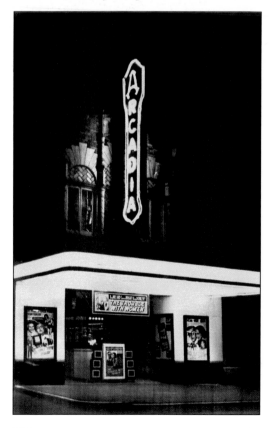

ARCADIA THEATRE. Again, a treasure from Temple's past is being brought into the city's future with careful renovation. As a city tourism brochure says, "The Arcadia Theatre was where Central Texans personally said 'Howdy' to Gene Autry, saluted Audie Murphy, waved to Roy Rogers, and grooved with Elvis." Built in 1928 by architect and engineer W.B. Palmer as a movie house and live performance theater, the Arcadia, located at 110 East Central, with its Art Deco motifs, seated 1,000 patrons and kept them comfortable with a state-of-the-art water-cooled air conditioning system. (Courtesy J.H. Roeder Collection.)

BIRD'S-EYE VIEW. Downtown Temple in 1955 looked a lot like downtown Temple today. There are subtle changes, however. Some buildings are gone while new ones have taken their place. It is all part of the story of how a railroad junction on the Blackland Prairie, a place that everyone called Mudville, became the Prairie Queen—Progressive Temple. (Courtesy J.H. Roeder Collection.)

TEMPLE VISITOR CENTER. One block west of the Municipal Building is the Visitor Center, the place to learn about Temple. Located in the heart of Central Texas on Interstate 35, the city is 60 miles north of Austin, 125 miles south of Dallas/Fort Worth, 140 miles north of San Antonio, 165 northwest of Houston, and is 682 feet above sea level (airport). Interstate 35 connects to Dallas/Fort Worth, Austin, San Antonio, and Laredo. State Highway 36 and US Highway 190 connect to Killeen/Fort Hood and west Texas, extending southeast to Houston. State highways 53 and 95 add easy access. The Draughon-Miller Central Texas Regional Airport is an FAA municipal facility with a 6,301-foot runway. Operated by the City of Temple, the airport is located six miles northwest of downtown. It has passenger and general aviation terminal facilities with ample free parking. Commercial airline service is available 15 miles southwest in Killeen, 40 miles north in Waco, and 65 miles south in Austin. Temple has daily AMTRAK passenger service, plus connecting and local bus service. And that is something about "Progressive Temple."